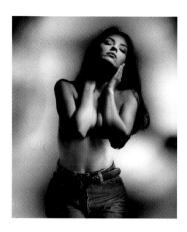

Pro·Lighting

NEW GLAMOUR

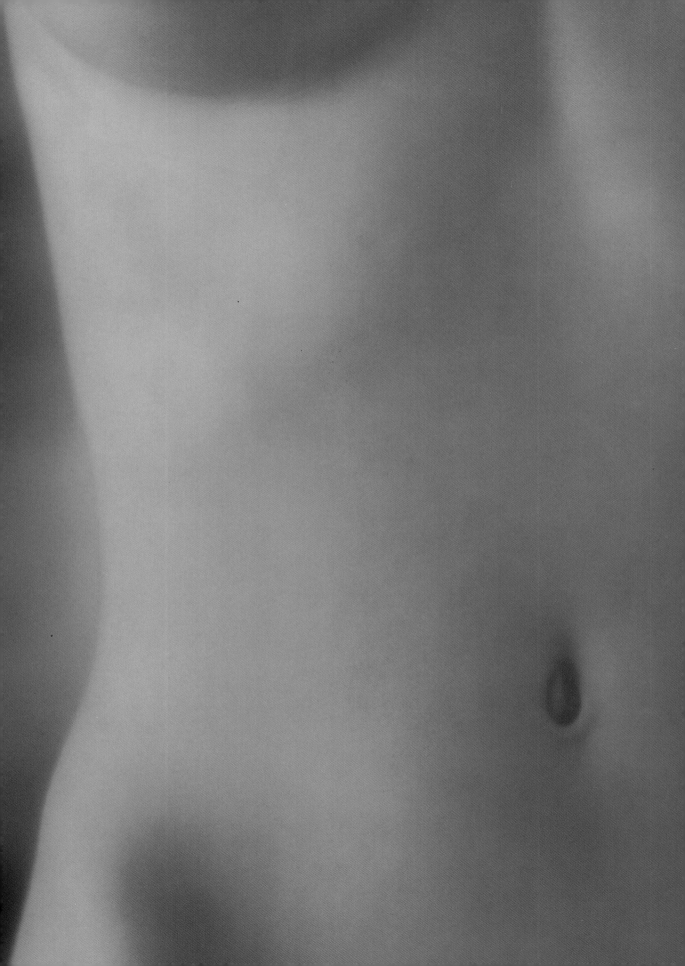

Pro·Lighting

ALEX LARG and JANE WOOD

NEW GLAMOUR

RotoVision

A Quintet Book

Published and distributed by
RotoVision SA
7 rue du Bugnon
1299 Crans
Switzerland

RotoVision SA Sales Office
Sheridan House
112/116A Western Road
Hove, East Sussex BN3 1DD
England
Tel: +44 1273 72 72 68
Fax: +44 1273 72 72 69

Distributed to the trade in the United States:
Watson-Guptill Publications
1515 Broadway
New York, NY 10036

ISBN 2-88046-322-X

This book was designed and produced by
Quintet Publishing Ltd
6 Blundell Street
London N7 9BH

Creative Director: Richard Dewing
Art Director: Clare Reynolds
Designer: Fiona Roberts
Senior Editor: Anna Briffa
Editor: Bill Ireson
Picture Researchers: Alex Larg and Jane Wood

Typeset in Great Britain by
Central Southern Typesetters, Eastbourne
Printed in Singapore
Production and Separation by ProVision Pte. Ltd.
Tel: +65 334 7720
Fax: +65 334 7721

CONTENTS

▼

THE PRO-LIGHTING SERIES

▼

THE MOST COMMON RESPONSE FROM THE PHOTOGRAPHERS WHO CONTRIBUTED TO THIS BOOK, WHEN THE CONCEPT WAS EXPLAINED TO THEM, WAS "I'D BUY THAT". THE AIM IS SIMPLE: TO CREATE A LIBRARY OF BOOKS, ILLUSTRATED WITH FIRST-CLASS PHOTOGRAPHY FROM ALL AROUND THE WORLD, WHICH SHOW EXACTLY HOW EACH INDIVIDUAL PHOTOGRAPH IN EACH BOOK WAS LIT.

Who will find it useful? Professional photographers, obviously, who are either working in a given field or want to move into a new field. Students, too, who will find that it gives them access to a very much greater range of ideas and inspiration than even the best college can hope to present. Art directors and others in the visual arts will find it a useful reference book, both for ideas and as a means of explaining to photographers exactly what they want done. It will also help them to understand what the photographers are saying to them. And, of course, "pro/am" photographers who are on the cusp between amateur photography and earning money with their cameras will find it invaluable: it shows both the standards that are required, and the means of achieving them.

The lighting set-ups in each book vary widely, and embrace many different types of light source: electronic flash, tungsten, HMIs, and light brushes, sometimes mixed with daylight and flames and all kinds of other things. Some are very complex; others are very simple. This variety is very important, both as a source of ideas and inspiration and because each book as a whole has no axe to grind: there is no editorial bias towards one kind of lighting or another, because the pictures were chosen on the basis of impact and (occasionally) on the

basis of technical difficulty. Certain subjects are, after all, notoriously difficult to light and can present a challenge even to experienced photographers. Only after the picture selection had been made was there any attempt to understand the lighting set-up.

This book is a part of the fourth series: BEAUTY SHOTS, NIGHT SHOTS, and NEW GLAMOUR. Previous titles in the series include INTERIOR SHOTS, GLAMOUR SHOTS, SPECIAL EFFECTS, NUDES, PRODUCT SHOTS, STILL LIFE, FOOD SHOTS, LINGERIE SHOTS and PORTRAITS. The intriguing thing in all of them is to see the degree of underlying similarity, and the degree of diversity, which can be found in a single discipline or genre.

Beauty shots feature beauty accessories and cosmetics for a commercial market so the lighting set-ups tend to be bright and strong to give powerful, bold images to grace the pages of many a beauty magazine or advertisement. Glamour shots, by contrast, concentrate on models, often nudes, and altogether softer lighting tends to be used, though having said that, many of the bold new-style shots are deliberately stark and provocative and the choice of harsher lighting can be used to good effect in these cases. For night shots, inevitably the use of available light without much by way

of additional lighting features much more prominently than in any other book in the series.

The structure of the books is straightforward. After this initial introduction, which changes little among all the books in the series, there is a brief guide and glossary of lighting terms. Then, there is specific introduction to the individual area or areas of photography which are covered by the book. Sub-divisions of each discipline are arranged in chapters, inevitably with a degree of overlap, and each chapter has its own introduction. Finally, there is a directory of those photographers who have contributed work.

If you would like your work to be considered for inclusion in future books, please write to Quintet Publishing Ltd, 6 Blundell Street, London N7 9BH and request an Information Pack. DO NOT SEND PICTURES, either with the initial inquiry or with any subsequent correspondence, unless requested; unsolicited pictures may not always be returned. When a book is planned which corresponds with your particular area of expertise, we will contact you. Until then, we hope that you enjoy this book; that you will find it useful; and that it helps you in your work.

HOW TO USE THIS BOOK

▼

THE LIGHTING DRAWINGS IN THIS BOOK ARE INTENDED AS A GUIDE TO THE LIGHTING SET-UP RATHER THAN AS ABSOLUTELY ACCURATE DIAGRAMS. PART OF THIS IS DUE TO THE VARIATION IN THE PHOTOGRAPHERS' OWN DRAWINGS, SOME OF WHICH WERE MORE COMPLETE (AND MORE COMPREHENSIBLE) THAN OTHERS, BUT PART OF IT IS ALSO DUE TO THE NEED TO REPRESENT COMPLEX SET-UPS IN A WAY WHICH WOULD NOT BE NEEDLESSLY CONFUSING.

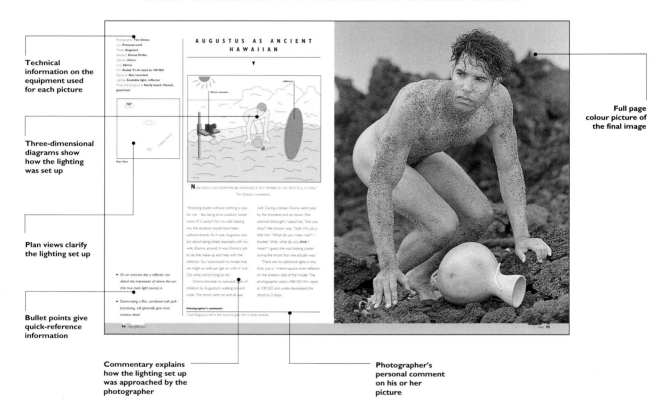

Technical information on the equipment used for each picture

Three-dimensional diagrams show how the lighting was set up

Plan views clarify the lighting set up

Bullet points give quick-reference information

Commentary explains how the lighting set up was approached by the photographer

Photographer's personal comment on his or her picture

Full page colour picture of the final image

Distances and even sizes have been compressed and expanded: and because of the vast variety of sizes of soft boxes, reflectors, bounces and the like, we have settled on a limited range of conventionalized symbols. Sometimes, too, we have reduced the size of big bounces, just to simplify the drawing.

None of this should really matter, however. After all, no photographer works strictly according to rules and preconceptions: there is always room to move this light a little to the left or right,

to move that light closer or further away, and so forth, according to the needs of the shot. Likewise, the precise power of the individual lighting heads or (more important) the lighting ratios are not always given; but again, this is something which can be "fine tuned" by any photographer wishing to reproduce the lighting set-ups in here.

We are however confident that there is more than enough information given about every single shot to merit its inclusion in the book: as well as purely

lighting techniques, there are also all kinds of hints and tips about commercial realities, photographic practicalities, and the way of the world in general.

The book can therefore be used in a number of ways. The most basic, and perhaps the most useful for the beginner, is to study all the technical information concerning a picture which he or she particularly admires, together with the lighting diagrams, and to try to duplicate that shot as far as possible with the equipment available.

A more advanced use for the book is as a problem solver for difficulties you have already encountered: a particular technique of back lighting, say, or of creating a feeling of light and space. And, of course, it can always be used simply as a source of inspiration.

The information for each picture follows the same plan, though some individual headings may be omitted if they were irrelevant or unavailable. The photographer is credited first, then the client, together with the use for which the picture was taken. Next come the other members of the team who worked on the picture: stylists, models, art directors, whoever. Camera and lens come next, followed by film. With film, we have named brands and types, because different films have very different ways of rendering colours and tonal values. Exposure comes next: where the lighting is electronic flash, only the aperture is given, as illumination is of course independent of shutter speed. Next, the lighting equipment is briefly summarized — whether tungsten or flash, and what sort of heads — and finally there is a brief note on props and backgrounds. Often, this last will be obvious from the picture, but in other cases you may be surprised at what has been pressed into service, and how different it looks from its normal role.

The most important part of the book is however the pictures themselves. By studying these, and referring to the lighting diagrams and the text as necessary, you can work out how they were done; and showing how things are done is the brief to which the *Pro Lighting* series was created.

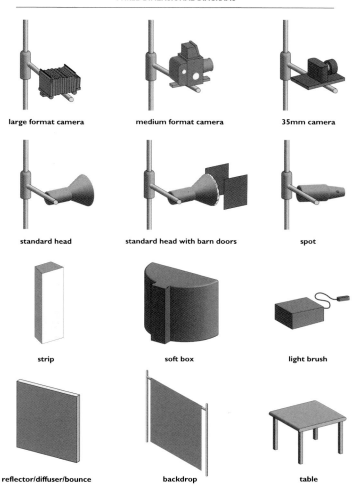

D I A G R A M K E Y

The following is a key to the symbols used in the three-dimensional and plan view diagrams. All commonly used elements such as standard heads, reflectors etc., are listed. Any special or unusual elements involved will be shown on the relevant diagrams themselves.

THREE-DIMENSIONAL DIAGRAMS

large format camera medium format camera 35mm camera

standard head standard head with barn doors spot

strip soft box light brush

reflector/diffuser/bounce backdrop table

PLAN VIEW DIAGRAMS

large format camera medium format camera 35mm camera bounce

gobo

standard head standard head with barn doors spot diffuser

reflector

strip soft box light brush backdrop table

GLOSSARY OF LIGHTING TERMS

▼

Lighting, like any other craft, has its own jargon and slang. Unfortunately, the different terms are not very well standardized, and often the same thing may be described in two or more ways or the same word may be used to mean two or more different things. For example, a sheet of black card, wood, metal or other material which is used to control reflections or shadows may be called a flag, a French flag, a donkey or a gobo — though some people would reserve the term "gobo" for a flag with holes in it, which is also known as a cookie. In this book, we have tried to standardize terms as far as possible. For clarity, a glossary is given below, and the preferred terms used in this book are asterisked.

Acetate
see Gel

Acrylic sheeting
Hard, shiny plastic sheeting, usually methyl methacrylate, used as a diffuser ("opal") or in a range of colours as a background.

***Barn doors**
Adjustable flaps affixed to a lighting head which allow the light to be shaded from a particular part of the subject.

Barn doors

Boom
Extension arm allowing a light to be cantilevered out over a subject.

***Bounce**
A passive reflector, typically white but also, (for example) silver or gold, from which light is bounced back onto the subject. Also used in the compound term "Black Bounce", meaning a flag used to absorb light rather than to cast a shadow.

Continuous lighting
What its name suggests: light which shines continuously instead of being a brief flash.

Contrast
see Lighting ratio

Cookie
see Gobo

***Diffuser**
Translucent material used to diffuse light. Includes tracing paper, scrim, umbrellas, translucent plastics such as Perspex and Plexiglas, and more.

Electronic flash: standard head with parallel snoot (Strobex)

Donkey
see Gobo

Effects light
Neither key nor fill; a small light, usually a spot, used to light a particular part of the subject. A hair light on a model is an example of an effects (or "FX") light.

***Fill**
Extra lights, either from a separate head or from a reflector, which "fills" the shadows and lowers the lighting ratio.

Fish fryer
A small Soft Box.

***Flag**
A rigid sheet of metal, board, foam-core or other material which is used to absorb light or to create a shadow. Many flags are painted black on one side and white (or brushed silver) on the other, so that they can be used either as flags or as reflectors.

***Flat**
A large Bounce, often made of a thick sheet of expanded polystyrene or foam-core (for lightness).

Foil
see Gel

French flag
see Flag

Frost
see Diffuser

***Gel**
Transparent or (more rarely) translucent coloured material used to modify the colour of a light. It is an abbreviation of "gelatine (filter)", though most modern "gels" for lighting use are actually of acetate.

***Gobo**
As used in this book, synonymous with "cookie": a flag with cut-outs in it, to cast interestingly-shaped shadows. Also used in projection spots.

"Cookies" or "gobos" for projection spotlight (Photon Beard)

***Head**
Light source, whether continuous or flash. A "standard head" is fitted with a plain reflector.

***HMI**
Rapidly-pulsed and

effectively continuous light source approximating to daylight and running far cooler than tungsten. Relatively new at the time of writing, and still very expensive.

***Honeycomb**

Grid of open-ended hexagonal cells, closely resembling a honeycomb. Increases directionality of

Honeycomb (Hensel)

light from any head.

Incandescent lighting

see Tungsten

Inky dinky

Small tungsten spot.

***Key or key light**

The dominant or principal light, the light which casts the shadows.

Kill Spill

Large flat used to block spill.

***Light brush**

Light source "piped" through fibre-optic lead. Can be used to add highlights, delete shadows and modify lighting, literally by "painting with light".

Electronic Flash: light brush "pencil" (Hensel)

Electronic Flash: light brush "hose" (Hensel)

Lighting ratio

The ratio of the key to the fill, as measured with an incident light meter. A high lighting ratio (8:1 or above) is very contrasty, especially in colour, a low lighting ratio (4:1 or less) is flatter or softer. A 1:1 lighting ratio is completely even, all over the subject.

***Mirror**

Exactly what its name suggests. The only reason for mentioning it here is that reflectors are rarely mirrors, because mirrors create "hot spots" while reflectors diffuse light. Mirrors (especially small shaving mirrors) are however widely used, almost in the same way as effects lights.

Northlight

see Soft Box

Perspex

Brand name for acrylic sheeting.

Plexiglas

Brand name for acrylic sheeting.

***Projection spot**

Flash or tungsten head with projection optics for casting a clear image of a gobo or cookie. Used to create textured lighting effects and shadows.

***Reflector**

Either a dish-shaped

surround to a light, or a bounce.

***Scrim**

Heat-resistant fabric

Electronic Flash: projection spotlight (Strobex)

Tungsten Projection spotlight (Photon Beard)

diffuser, used to soften lighting.

***Snoot**

Conical restrictor, fitting over a lighting head. The light can only escape from the small hole in the end, and is

therefore very directional.

***Soft box**

Large, diffuse light source made by shining a light

Tungsten spot with conical snoot (Photon Beard)

Electronic Flash: standard head with parallel snoot (Strobex)

through one or two layers of diffuser. Soft boxes come in all kinds of shapes

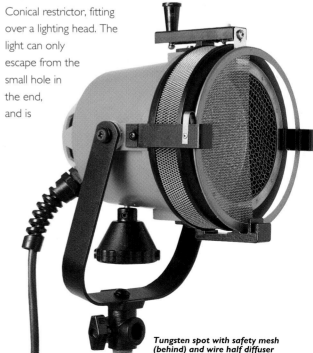

Tungsten spot with safety mesh (behind) and wire half diffuser scrim (Photon Beard)

Electronic flash: standard head with large reflector and diffuser (Strobex)

and sizes, from about 30×30cm to 120×180cm and larger. Some soft boxes are rigid; others are made of fabric stiffened with poles resembling fibreglass fishing rods. Also known as a northlight or a windowlight, though these can also be created by shining standard heads through large (120×180cm or larger) diffusers.

***Spill**

Light from any source which ends up other than on the subject at which it is pointed. Spill may be used to provide fill, or to light backgrounds, or it may be controlled with flags, barn doors, gobos etc.

***Spot**

Directional light source. Normally refers to a light using a focusing system

Tungsten spot with removable Fresnel lens. The knob at the bottom varies the width of the beam (Photon Beard)

with reflectors or lenses or both, a "focusing spot", but also loosely used as a reflector head rendered more directional with a honeycomb.

***Strip or strip light**

Lighting head, usually flash, which is much longer than it is wide.

Electronic flash: strip light with removable barn doors (Strobex)

Strobe

Electronic flash. Strictly, a "strobe" is a stroboscope or rapidly repeating light source, though it is also the name of a leading manufacturer.

Strobex, formerly Strobe Equipment.

Swimming pool

A very large Soft Box.

***Tungsten**

Incandescent lighting. Photographic tungsten

Electronic flash: standard head with standard reflector (Strobex)

lighting runs at 3200°K or 3400°K, as compared with domestic lamps which run at 2400°K to 2800°K or thereabouts.

***Umbrella**

Exactly what its name suggests; used for modifying light.

Umbrellas may be used as reflectors (light shining into the umbrella) or diffusers (light shining through the umbrella). The cheapest way of creating a large, soft light source.

Windowlight

Apart from the obvious meaning of light through a window, or of light shone through a diffuser to look as if it is coming through a window, this is another name for a soft box.

Tungsten spot with shoot-through umbrella (Photon Beard)

NEW GLAMOUR

▼

WHAT IS "NEW GLAMOUR"? GLAMOUR IS AN AGE-OLD THEME THAT CARRIES AS MUCH FASCINATION TODAY AS IT EVER DID; BUT TIMES ARE CHANGING AND CREATIVE ARTISTS ARE FOREVER LOOKING FOR NEW APPROACHES TO FAMILIAR TERRITORY — AND SEEKING OUT NEW TERRITORIES ACROSS OLD BOUNDARIES, EXPLORING IDEAS THAT AT ONE TIME WOULD HAVE BEEN UNTHINKABLE.

What was once considered too "strong" for widespread consumption has now become more widely acceptable and commonplace. At the same time, an interesting deviation from this line of thought has developed as the audiences have become more sophisticated and are no longer satisfied with all-too-accessible, unsubtle imagery. A trend has developed for a more visually literate approach, where there is room for artistic presentation that has strong powers of suggestion. Absolute nudity is no longer as erotic as it gets. There is room, and an audience now, for a more subtle approach.

This is largely because glamour work has come to be used in a far more widespread way than ever before. No longer the province exclusively of the top shelf, bold glamour work now graces every magazine, bill-hoarding and greetings card and poster shop. The photographs in this book demonstrate how creative, world-class photographers are rising to the challenge of providing appropriate imagery for this ever-developing market.

One indication of the close relationship between photography and other visual arts is the extent to which many of the photographers featured treat the glamour subject matter as fine art material, an opportunity to explore the range of composition and subject, sometimes in a surprisingly detached and impersonal way. This is particularly true of the "Body Parts" chapter (Chapter 2, pages 38 – 55), but a similar quality of detachment is evident elsewhere too. Even in such a picture as "Bondage" (page 137), which might be expected to portray intimacy and passivity in an extreme form, is in fact just as much a study of the forms, textures and patterns caused by the ropes; while the model, far from looking passive or oppressed in any way, looks up with an expression of detached coolness. The result is an erotic but not voyeuristic image.

This shot is in fact representative of a particularly noticeable and interesting feature of many of the images in this book: the lack of passivity of the models. At one time an air of passivity was an almost obligatory aspect of glamour shots, but nowadays women tend to be portrayed in a less patronizing and belittling way; in the world of commercial and art photography at least. The market demands a more sophisticated and modern approach, and the models in these shots take their place in the world as active participants, not as passive objects.

THE GLAMOUR IMAGINATION

Glamour is a subject area that is very much prone to the changes of fashion. The taste for forms of beauty, props, fantasy scenarios, expression and mood have all changed immensely over the years. What is glamorous, sophisticated or outrageous at one time can seem amusingly dated, tame and gauche when viewed with some years' perspective. It is part of the photographer's role to be aware of the tastes of the moment and to produce a fantasy image that either chimes uncontroversially with the popular imagination of the moment, or, quite often, pushes public taste one step further than is commonplace in order to make a strong impact, challenge assumptions and thus, of course, capture attention – the commercial raison d'être of much glamour work.

An important aspect of capturing the mood of the times for this kind of work stems from observation. As a background for glamour photography, as for any other branch of photography, it is essential for the photographer to be always collecting ideas, noticing details and interesting effects that occur in everyday life, to build up the information in a mental library of ideas, giving a stock of inspiration to draw on for a shoot.

The flip side of this is to use the imagination to envisage what "might be" rather than what has been observed and witnessed at first hand. Glamour

photography is an imaginative, fantasy area, and it is equally important to try out ideas and experiment, to turn internal imaginings into external realizations.

CAMERAS, LENSES AND FILMS FOR GLAMOUR SHOTS

Unsurprisingly, medium format has been used by many of the photographers featured in this book, since it gives good definition while still allowing quick working in an area where close detail in the final image will be essential and spontaneity during the shoot will be paramount. Many photographers have also used 35mm, either for convenience or possibly because it gives more the "look" that they require. The 35mm negative or transparency inherently requires more enlargement in the reproduction process and thus gives larger grain and adds to the texture of the final image. Having said that, with modern film stock technology, grain is finer on certain films so a photographer needs to know the whole range of stocks on the market and choose the right one for the moment. It is noticeable that Polaroid 35mm instant stocks have been used quite widely. They give instant results, useful for checking "work in progress" during what might be a relatively "free", experimental session. Polaroid stocks are also popular for glamour shoots because of the graphic, contrasty image that they can give, which is appropriate for the "fine art" look often required in glamour work. More and more, Polaroid film is used for the end result, not just as an interim stage before going on to shoot on some other stock.

Interestingly, very few of the photographers featured in this book have used 10x8 plate cameras, which at one time would have been a more widely-used format. The relatively small, lightweight, modern electronic cameras have obvious appeal and versatility and it may be that the older larger formats are simply being used less, so newer assistants and practitioners in studios coming into the trade have less experience and familiarity with the format - and so the decline in usage continues. This seems a pity, for anyone who has handled a 10x8 trannie (such as the original radiant transparency of "Stomach" by Rob Maclese, pages 48 – 49) will know what marvellous quality can be attained: a perfect transparency of such size is a sheer delight to hold and behold.

LIGHTING EQUIPMENT FOR GLAMOUR SHOTS

A range of equipment is needed for the glamour shoot. The basic kit used most frequently by the photographers featured in this book consists of various permutations of soft boxes, standard heads and silver, gold, white and black reflectors, and the occasional ring flash. A plethora of devices for modifying light is always useful, for example honeycombs, diffusing screens, coloured gels, umbrellas and filters.

Since glamour work will frequently involve bare skin as part of the subject, it is important to know how different filters and gels can enhance the range of skin tones to give the look required, especially as Polaroid tests cannot be relied upon for giving an indication of colour, but only

for exposure and contrast. Many of the shots in this book include warm-up orange filters to give tanned-looking skin, while contrast filters to give more graphic body forms are also frequently used.

The texture and colour of the subject's skin will of course influence the lighting set-up chosen. For bright, burnt out skin a close-in light source will be appropriate. For more graduation and fall-off of light on curved surfaces, carefully placed black panels will be useful. Different types of light (focusing spots, reflectors soft boxes, ring flashes) will all give different kinds of catch-lights in eyes, and choice of lighting on specific details (e.g. a focusing spot to pick out the texture of hair) can make all the difference.

THE TEAM

The team for a glamour shoot may be large or small. At the absolute minimum there may be only the photographer, doubling up as the model in order to make spontaneous use of the light of the moment (see Julia Martinez's "Innocence" on page 35, for example). More usually, though, from the photographer's point of view a good make-up artist and stylist will be needed, as well as an assistant or two. If a client is involved, there may well also be an agency art director present at the shoot, representatives of the client and other marketing and publicity staff.

The professional model will take all this in his or her stride, but nevertheless it is still probably true to say that for the intimate work that glamour photography entails, a rapport between photographer and model(s), and, indeed, between the models themselves, if a couple or group

are involved, will often be established most naturally and effectively without an unnecessarily large audience of onlookers. For this reason the photographer may want and need to establish a comfortable, sympathetic atmosphere before the actual shoot starts. It is important that the model should know exactly what is required from the shoot beforehand to avoid any misunderstandings or awkward refusals at a crucial stage of a shoot, though an element of spontaneity may also be important. The choice of a natural, imaginative, spontaneous and responsive model will help enormously.

LOCATION AND SETTING

There are two main considerations with regard to settings. The initial choices are whether the shoot is to take place on location or in the studio.

Within the location option there are thousands of variables to weigh up. Is the setting what is being advertised? Is the setting an essential context for the use of the product? Is the choice of an exact setting (for example, the Bahamas) an essential prerequisite, or will a generic brief (for example a sunny beach) be adequate? Whose decision is that anyway? Who will research the exact location? If it is not the photographer, then it must be someone with a good awareness of the lighting considerations (direction of the sun, shadow-casting buildings and trees, for example) as well as an eye for a photogenic spot. Who has to approve the final choice of location? Are there any release considerations for shoots on private property or of particular sites? Could the location be simulated more conveniently

and cost-effectively in the studio instead? Is this an option? Most importantly, who will pay for what?

If a studio set can be used instead, this can give infinitely more control over the variables. The set itself can be built to facilitate the ideal viewpoint; for example a room setting for an interior shot can be constructed without all the walls of a real interior, for the camera's convenience. Even the weather is available on demand: wind can be simulated to order, as can mist, fog, rain, snow, angle and intensity of sunshine, and so on.

The drawback can be the cost and time involved in building a very elaborate, detailed or difficult set. While for some sets the basic studio props can be adequately arranged by the photographer and/or stylist, for others a large set-construction team is required, consisting of a construction manager co-ordinating a team of carpenters, electricians, painters, and others. Props may have to be hired, which then involves the administration and co-ordination skills and time of a production manager, liaising with out-of-house suppliers. The budget for all this needs to be calculated accurately beforehand and then watched closely when the shoot goes ahead.

MOOD, STYLING AND LIGHTING

Obviously a primary concern for a glamour shoot is the mood created by both the styling (costume, setting, model posing) and by the lighting selected by the photographer, whether from artificial sources or natural available light. Whatever the initial source of light favoured, it will, of course, probably have

to be modified to some degree to give the exact required quality, ranging from as hard as possible or very soft.

Colour is a major contributory factor when it comes to creating a particular mood or feel, as is widely recognized in everyday life. Think of the common associations of colour with mood: red for anger, blue for coolness, green as a soothing, relaxing hue. From a practical point of view, remember, too, that certain colours are also thought by some people to be unlucky and can engender a great deal of superstition (something to be aware of if any member of the team turns out to be particularly superstitious about the presence of the colour green on set, for example).

Although the photographer may have in mind the exact look that he or she wants, as with everything there have to be practical considerations too. Sometimes there are unexpected intrinsic limitations to the location of the shoot, for example very little space for positioning of lamps, problems of proximity in terms of focal lengths, difficulty with feeling comfortable for the photographer, assistants and, possibly most importantly, the model. All of these can necessitate some quick-thinking creative solutions on the part of the photographer. The mood, styling and lighting may have to be adapted at the last minute to accommodate the unforeseen. The answer is, of course, to minimize the possibility of surprises on the day by thoroughly researching and preparing for the shoot beforehand as far as possible. Nevertheless, it is always necessary to keep an open mind and to be prepared for anything!

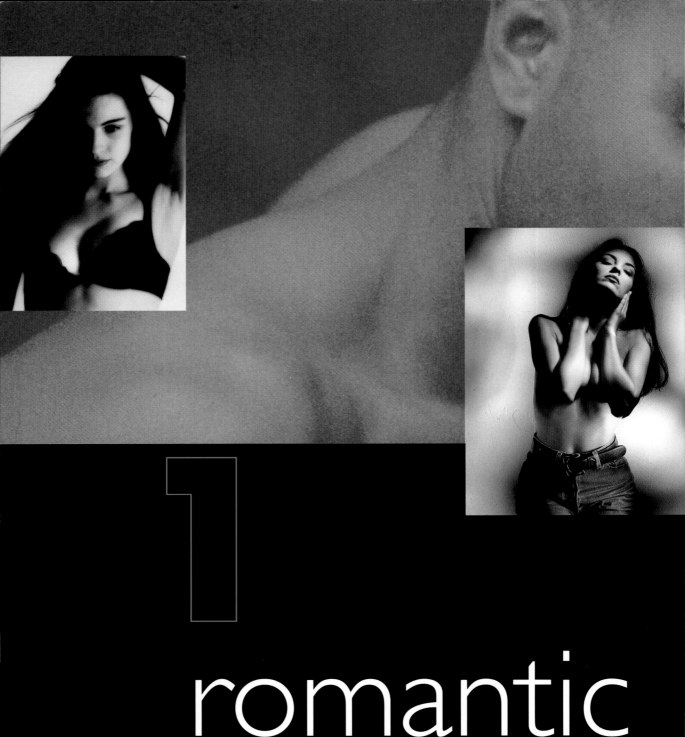

romantic

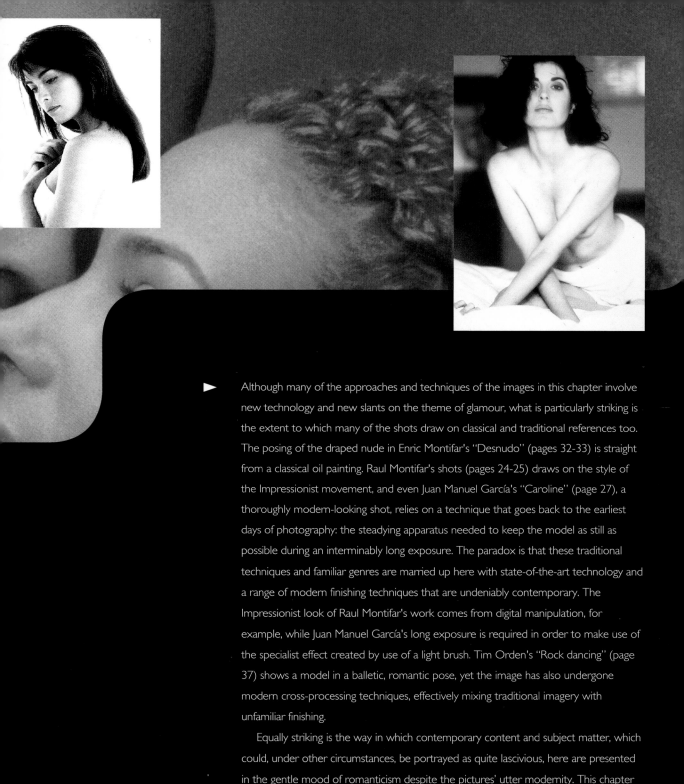

Although many of the approaches and techniques of the images in this chapter involve new technology and new slants on the theme of glamour, what is particularly striking is the extent to which many of the shots draw on classical and traditional references too. The posing of the draped nude in Enric Montifar's "Desnudo" (pages 32-33) is straight from a classical oil painting. Raul Montifar's shots (pages 24-25) draws on the style of the Impressionist movement, and even Juan Manuel García's "Caroline" (page 27), a thoroughly modern-looking shot, relies on a technique that goes back to the earliest days of photography: the steadying apparatus needed to keep the model as still as possible during an interminably long exposure. The paradox is that these traditional techniques and familiar genres are married up here with state-of-the-art technology and a range of modern finishing techniques that are undeniably contemporary. The Impressionist look of Raul Montifar's work comes from digital manipulation, for example, while Juan Manuel García's long exposure is required in order to make use of the specialist effect created by use of a light brush. Tim Orden's "Rock dancing" (page 37) shows a model in a balletic, romantic pose, yet the image has also undergone modern cross-processing techniques, effectively mixing traditional imagery with unfamiliar finishing.

Equally striking is the way in which contemporary content and subject matter, which could, under other circumstances, be portrayed as quite lascivious, here are presented in the gentle mood of romanticism despite the pictures' utter modernity. This chapter demonstrates the meeting of two movements: the traditional and the new,

Photographer: **Frank Wartenberg**

Client: *Foto Magazine*

Use: **Editorial - cover shot**

Model: **Jacqueline**

Assistant: **Jan**

Stylists: **Karin and Matina**

Camera: **35mm Nikon F4**

Lens: **105mm**

Film: **Agfa Scala**

Exposure: **Not recorded**

Lighting: **Available light**

Props and background: **Studio**

Plan View

► *This shot demonstrates how effectively natural daylight flooding through a window can take the place of a soft box in a studio*

► *It is essential with sunlight to work quickly: the lighting conditions are always changing*

C O V E R G I R L

▼

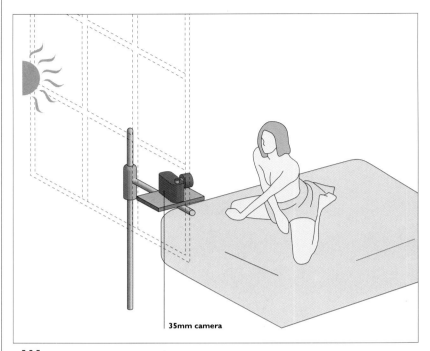

35mm camera

WITH THE BENEFIT OF A WINDOW AT THE RIGHT HEIGHT, OF THE RIGHT SIZE AND FACING IN THE RIGHT DIRECTION, IT IS POSSIBLE TO LIGHT A SHOT BRIGHTLY AND PURELY WITH THE AVAILABLE LIGHT, EVEN IN AN INTERIOR SETTING SUCH AS THE STUDIO USED HERE.

The model faces a large window that provides bright (but not harsh) light, which is spread evenly across the body. The pose creates opportunities for gentle shadows to give gentle modelling outlines to the figure.

Compositionally it is significant that some of the fingers and part of a foot should be visible. If you cover the bottom edge of the shot to conceal these, their importance is obvious: the shot looks unbalanced and the limbs of the model seem to disappear out of frame all too abruptly, giving a disconcerting lack of "geography" to the body.

The directness of the expression engages the viewer and the minimal clothing and careful pose combine, partly to reveal, partly to conceal the body, adding immeasurably to the allure and intimacy of the shot.

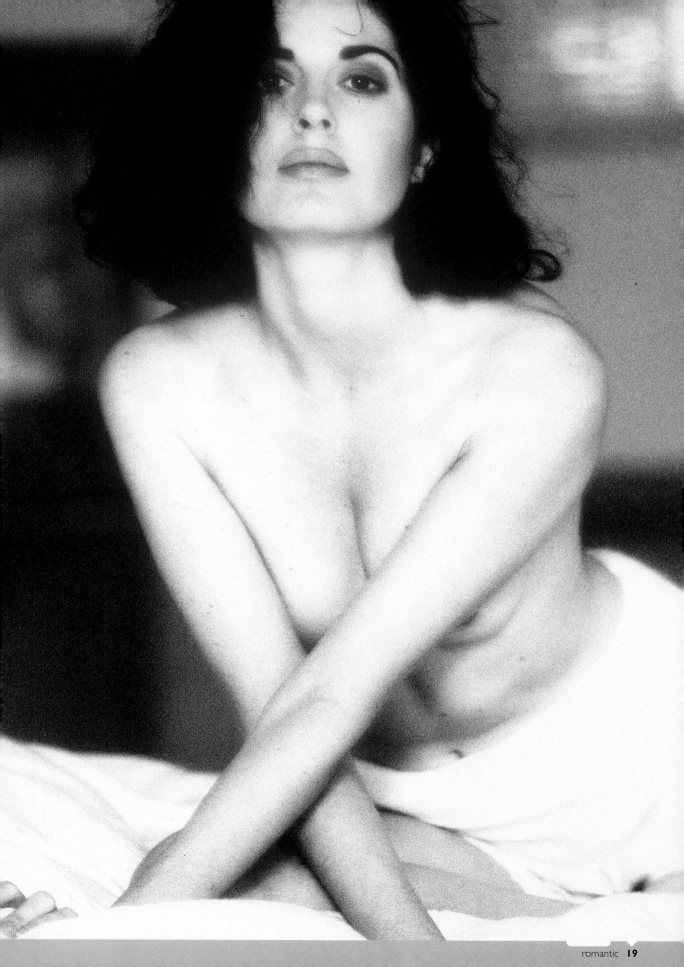

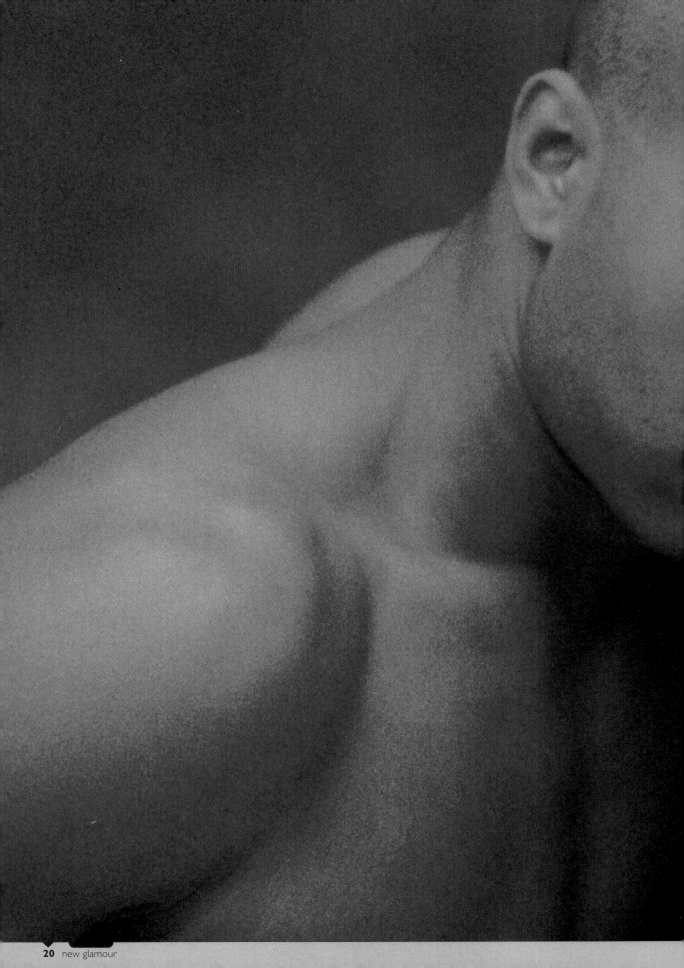

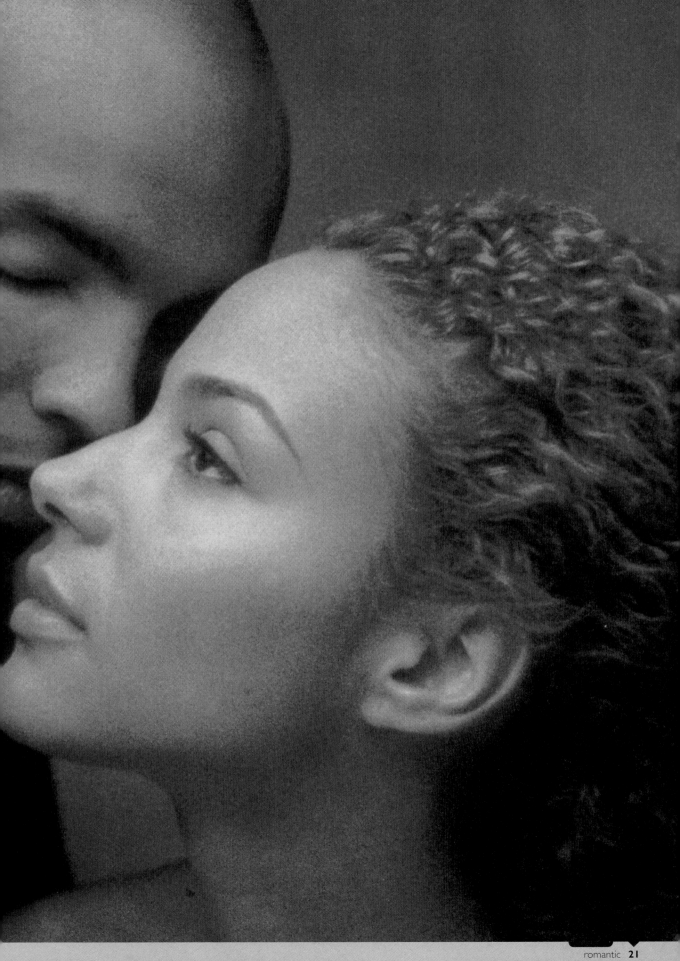

Photographer: **Holly Stewart**

Client: **Self-promotion**

Use: **Portfolio**

Models: **Cynthia and Phillip at Mitchell**

Camera: **35mm**

Lens: **60mm**

Film: **Kodak 100SW**

Exposure: **1/60 second at f/5.6**

Lighting: **Electronic flash and tungsten**

Props and background: **Painted canvas**

Plan View

▼

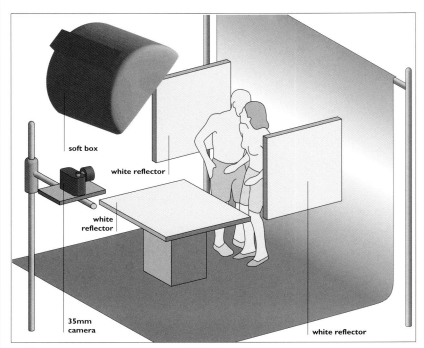

THIS SHOT EMANATES MUCH WARMTH OF TONE. THE CHOICE OF FILM, KODAK 100SW, GIVES GOOD COLOUR SATURATION AND A WARM LOOK. THE PAINTED CANVAS BACKDROP COMPLEMENTS THE SKIN COLOUR OF THE MODELS BUT DOES NOT COMPETE WITH THEM FOR PROMINENCE IN THE SHOT.

The background is not lit independently, so although the colour tone is in a similar hue, it is not as brightly lit as the models are and so the background area remains firmly *in* the background.

The models themselves are lit by a single central soft box, causing highlights on the upturned face and shoulders, and three reflectors, giving an amount of fill. The placing of the models results in areas of deep shadows where they both flag each other (on the far shoulder and chest in each case), and the woman's head is tilted away from the light to give an area of dark tones at the back of the head.

► *Black hair absorbs a lot of light and a large amount of light is needed to register a high level of detail*

► *Positioning one model further away from the camera than the other raises considerations of depth of field*

Photographer: **Raul Montifar**

Client: **White Castle**

Use: **Calendar**

Art director: **Raul Montifar**

Camera: **Mamiya RB67**

Lens: **180mm**

Film: **Kodak EPP**

Exposure: **f/16**

Lighting: **Electronic flash: 2 heads**

Plan View

► *Emulating the works of the Old Masters, paying particular attention to the observation of light, is excellent groundwork for a photographer*

► *Software packages offer many filtration options, so it may be more convenient to shoot without lens filters initially*

I M P R E S S I O N I S T

▼

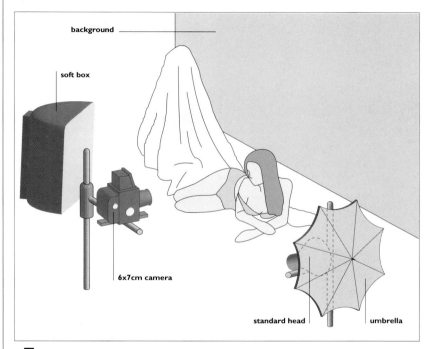

THE POSE AND CONTENT OF THIS SHOT ARE THE STUFF OF MANY A NINETEENTH-CENTURY OIL PAINTING. THE SUBJECT MATTER AND STEADY GAZE OF THE MODEL BRING TO MIND THE UNABASHED DIRECTNESS OF MANET'S "OLYMPIA" (THOUGH THIS MODEL IS MORE DISCREETLY DRAPED), WHILE THE BOLD BRUSH-STROKE TEXTURES ADD TO THE ILLUSION THAT THIS IMAGE OWES MORE TO PAINT THAN IT DOES TO FILM.

Of course, the image does owe a debt of inspiration to the great Impressionist painting tradition, as well as to film, but the third element is computer technology, which has been used to distort in a very particular way: the program gives a specifically broad-brush Impressionist look to the basic photographic image.

The correct choice of lighting is essential to the success of this image. Painters, like photographers, are interested in portraying the effects of light, and the careful choice of subject,

composition and lighting in this shot takes just the same concerns into account. Attention has been paid to graduated lighting on the skin tones and hair, as well as overall composition: the choice of fabric drapes and posing gives opportunities for the play of light on textiles and human textures that were often the very point of such paintings. Equipment comprises a soft box to camera left, measuring f/16 and a fill light to camera right, a standard head shooting into an umbrella, reading f/8.5. There is also a warm filter over the camera lens.

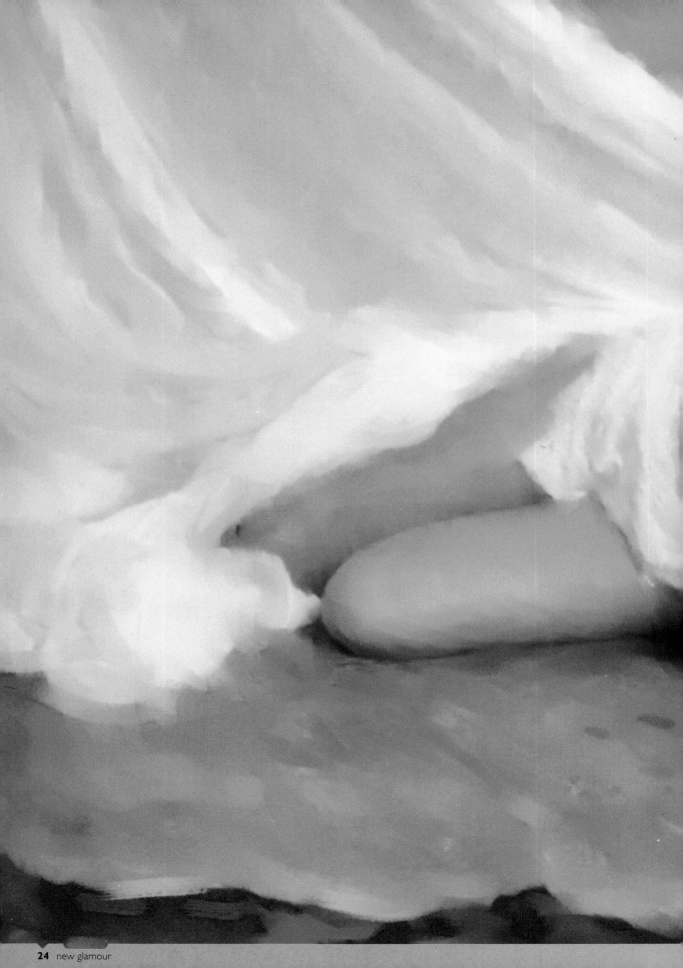

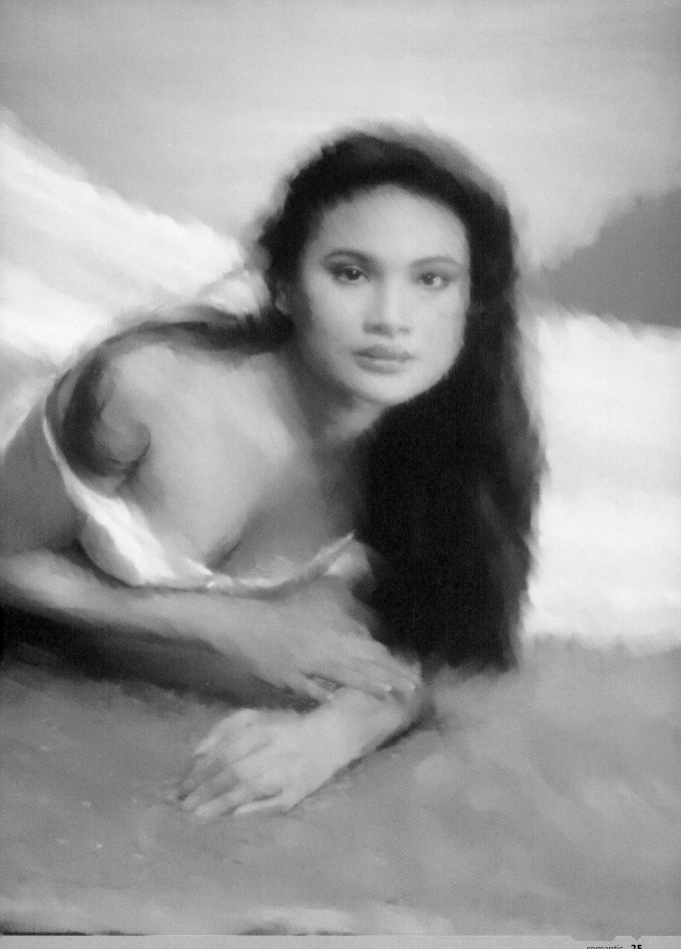

Photographer: **Juan Manuel Garcia**

Client: **La Agencia - Miami**

Use: **Advertising**

Model: **Caroline Gómez**

Assistants: **Carlos Barrera, Carlos Bayora**

Stylist: **Alejandro Ortíz**

Camera: **6x6cm**

Lens: **150mm**

Film: **Ektachrome 100**

Exposure: **90 seconds**

Lighting: **Light brush**

Props and background: **Blue velvet background, support for model to lean on**

Plan View

► *It is interesting to note that the light brush was held only 50cm from the model. This means that for the whole duration of the exposure there was actually another person, the photographer, in frame, wielding the lightbrush - but he is not visible in the final image because there was no light falling on him*

► *To complement the effect of light brushing, diffusion can be used on the camera lens*

► *Light intensity and balance can also be altered by changing the power and aperture or by making multiple exposures*

CAROLINE

▼

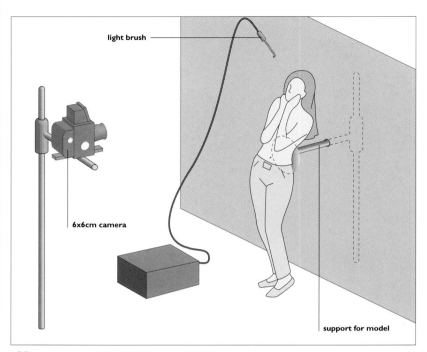

light brush

6x6cm camera

support for model

Use of a light brush allows close control of the illumination on every part of the frame, so it enables the photographer to create the exact type of light that is needed for the mood of the photo. However, it also requires a lengthy exposure, and the stillness of the model is very important. For this reason Juan Manuel García used a steadying apparatus that was positioned behind the model for her to lean on and which minimized any movement during the 90-second exposure.

The light brush was applied with smooth movements, with a distance of approximately 50cm between the light and the point illuminated. Then a blue filter was used on the point of the light, to increase the small size of the light and to record the background area around the model with quick movements. The main factors when using the light brush are the accessories used, the direction of the light, the movement of the light brush, the distance between the light brush and the model and the precise length of exposure. The stillness of the model is very important, hence the support system used here.

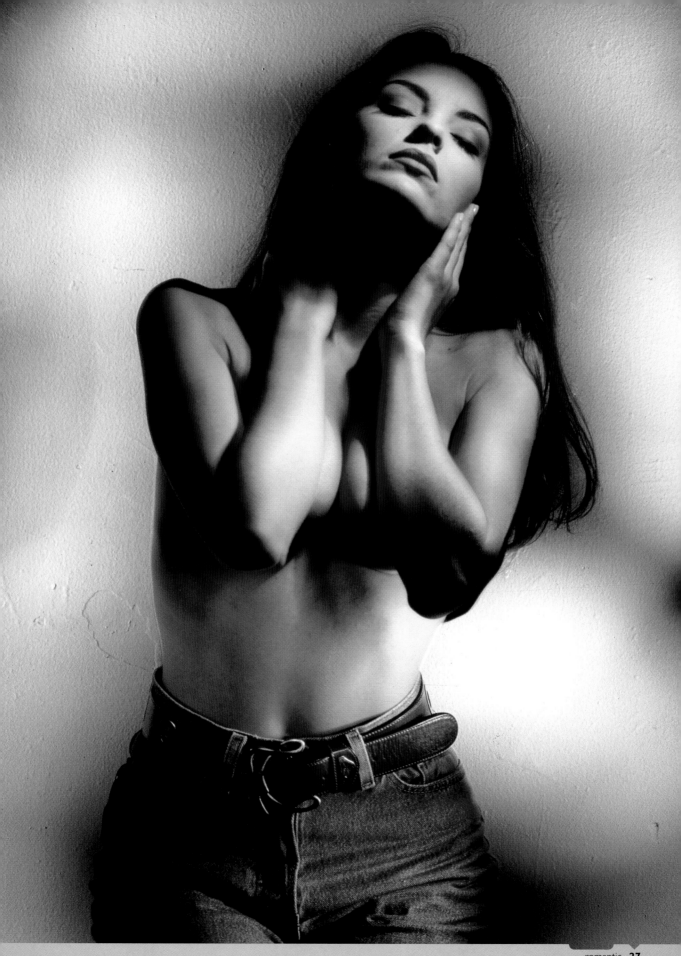

Photographer: **Terry Ryan**

Client: **Model and picture library**

Use: **Self-promotion**

Model: **Suzi**

Assistant: **Nicolas Hawke**

Camera: **35mm**

Lens: **105mm**

Film: **Polaroid Polagraph**

Exposure: **f/16**

Lighting: **Electronic flash: 2 heads**

Props and background: **White scoop**

Plan View

► *Polagraph film can be developed instantly, a definite plus in a studio enabling the photographer to check the lighting "on the hoof" as the shoot progresses*

► *Low-contrast lighting is essential if you want a good tonal range with high-contrast material*

SERIES

▼

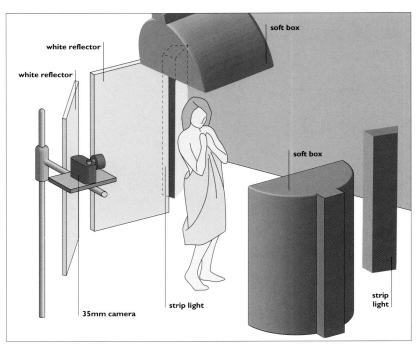

THE LIGHTING CONSISTS OF TWO 5-FOOT STRIP LIGHTS LIGHTING THE BACKGROUND, TWO SOFT BOXES AIMED AT THE MODEL (ONE TO THE SIDE IN FRONT, AND ONE OVERHEAD) AND FINALLY TWO WHITE REFLECTORS BOUNCING LIGHT IN ON THE SHADOW SIDE OF THE MODEL. THE SET-UP REMAINED THE SAME FOR THE WHOLE SHOOT, AS DID THE CAMERA SETTINGS AND CHOICE OF MODEL. THE INTEREST OF THIS SERIES IS THAT IT REPRESENTS A VISUAL DIARY OF A SHOOT, WITH THE MODEL DIRECTED TO TRY A VARIETY OF POSES AND THE PHOTOGRAPHER SIMULTANEOUSLY EXPERIMENTING WITH DIFFERENT FRAMING AND PERSPECTIVE.

In any shoot, some shots will prove to be more successful than others, and the enlarged shot from this series is amongst Terry Ryan's preferred results from the session.

It is instructive to observe how very different the mood and feel of the shots can be, solely as a result of the pose of the model – whether she is facing the camera or has her back to the lens; whether she is looking out at the viewer or averting her eyes; her expression.

While some shots verge on the territory of art photography, recalling draped classical statues, others would not be out of place in any glamour setting.

The choice of Polagraph film, which is a high-contrast stock, means that, in order to achieve a good tonal range, a very tight lighting ratio is required. Hence the choice of a soft box, which gives a good, even, diffused light, and the use of reflectors, which reduce the ratio even more.

Photographer: **Enric Monte**

Use: **Self-promotion**

Model: **Isabel**

Assistant: **Carles Guinot**

Camera: **6x7cm**

Lens: **180mm**

Film: **Ektachrome 64T**

Exposure: **1/2 second at f/8**

Lighting: **Tungsten**

Props and background: **Painted draped background**

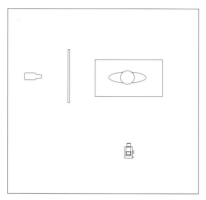

Plan View

D E S N U D O

▼

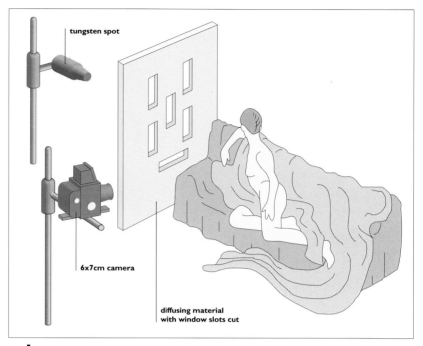

INSPIRATION FROM THE ANCIENT WORLD IS IMMEDIATELY OBVIOUS IN THE POSING AND DRAPERY OF THIS SHOT AND THE CLASSICAL OIL PAINTING FEEL IS DELIBERATE. ENRIC MONTE WAS SPECIFICALLY SETTING OUT TO CREATE "A CERTAIN PAINTERLY AIR."

The lighting is very simple. A single tungsten spot to camera left is directed through a sheet of diffusing material, the spot being about 3m away from the model. The panel has small "windows" cut out of it so that some direct light comes through the holes without any diffusion and creates the hot spot areas on the model. The remainder of the light is diffused through the panel, giving softer and more even light elsewhere in the frame. The panel is about half-way between the light and the model, so the pools of direct light are not sharply focused but still give the dappled effect that is required.

The use of a tungsten balanced film gives correct colour rendition but is combined here with an 82A "cool-down" filter, which then combines with the soft filter to give the milky blue-white tinge.

► *"Correct" exposure is not necessarily correct for every shot*

► *The position of the "windows" in relation to the subject determines the focus of the hot spots*

Photographer's comment:

This photograph aims for a certain painterly air.

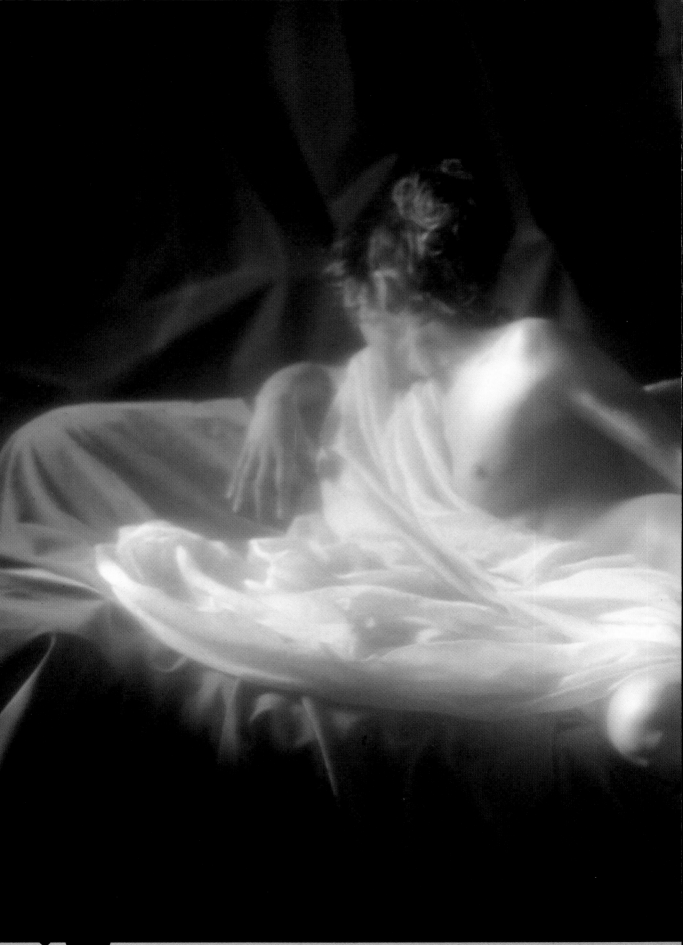

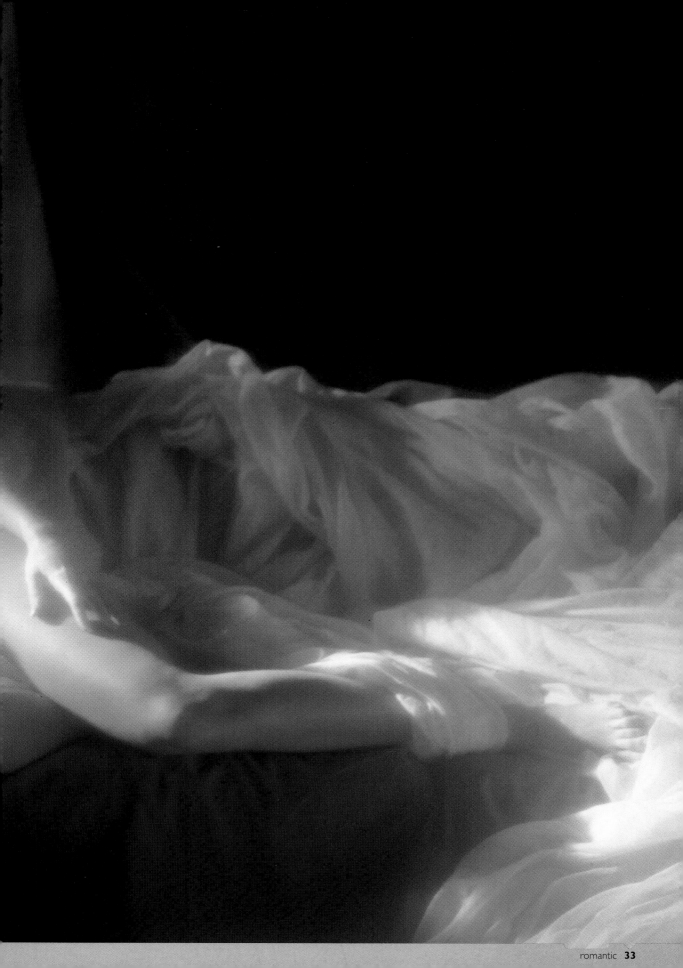

Photographer: **Julia Martinez**

Use: **Personal work**

Camera: **Mamiya 645**

Lens: **90mm**

Film: **Tmax 100**

Exposure: **f/11**

Lighting: **Electronic flash**

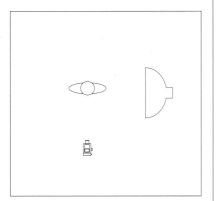

Plan View

INNOCENCE

▼

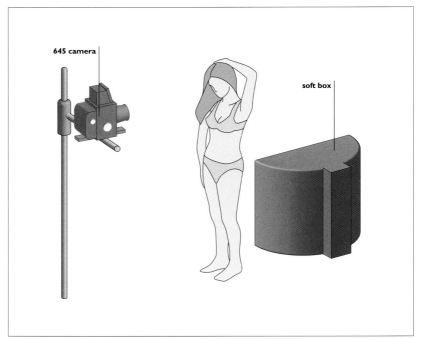

645 camera

soft box

THIS SHOT DEMONSTRATES THE IMPORTANCE OF ALWAYS BEING AWARE AND ALERT AND ON THE LOOK-OUT FOR A POTENTIAL SHOT. JULIA MARTINEZ HAD FINISHED THE MAIN SESSION OF A SHOOT AND THE MODEL WAS DRESSING AND RE-ARRANGING HER HAIR AFTER THE MAIN BUSINESS OF THE DAY WAS OVER.

As the model swept back her hair Julia noticed the potential for another interesting shot and, as she had one last frame left on the film, she quickly called "Hold it!", and swiftly took the shot as the model pause for a moment, standing in the light of just one soft box.

In the circumstances there was no time to set up reflectors, so this is lit purely by the soft box. The side of the face goes into almost complete shade, but there is enough light there to give the impression of the face. The model's colouring and the clothing combine to give a strong chiaroscuro effect. The result is a stylish look and a balanced picture.

► *There isn't time to set up lighting with opportunistic shots. The "experimental" element that this introduces can give interesting results*

► *A photographer needs to know how different film stocks react to light - what contrast they will give*

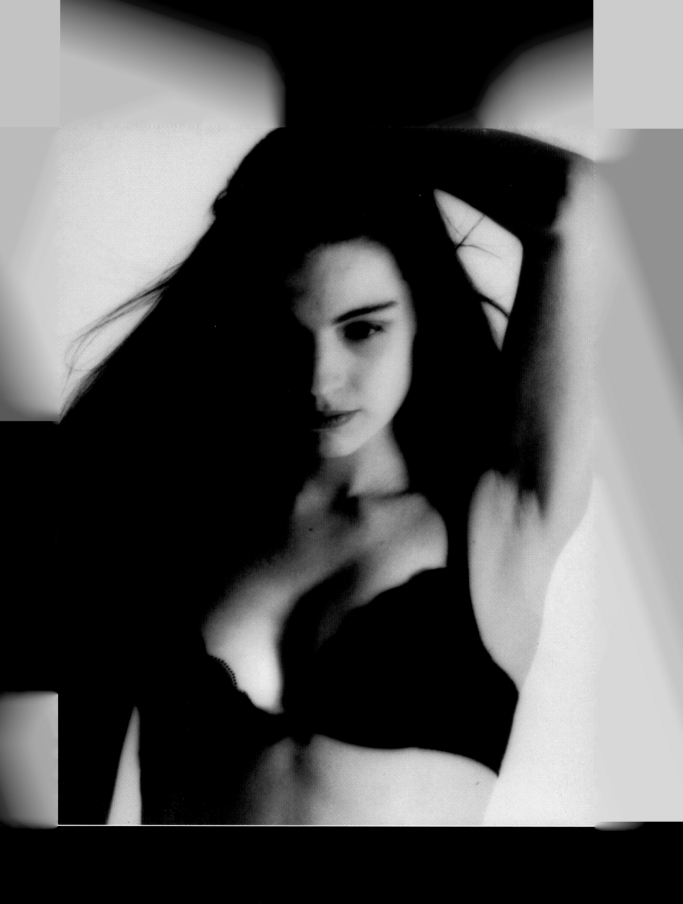

Photographer: **Tim Orden**

Use: **Personal work**

Model: **Sasha**

Assistant: **Donna Orden**

Stylist: **Donna Orden**

Camera: **35mm**

Lens: **60mm**

Film: **Fuji Velvia rated at 100 ISO cross-processed**

Exposure: **1/250 second at f/5.6**

Lighting: **Electronic flash, available light**

Props and background: **Hawaiian beach**

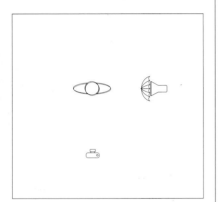

Plan View

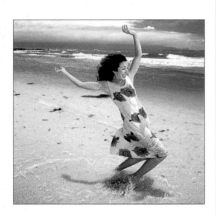

▶ *Informal moments can be as interesting as the more posed moments*

▶ *Notice the difference that the presence of the sand makes to the look: it acts as a reflector*

▶ *The background is very saturated colour, partly because of the choice of film and processing, but also because the camera is looking towards the sun*

ROCK DANCING

▼

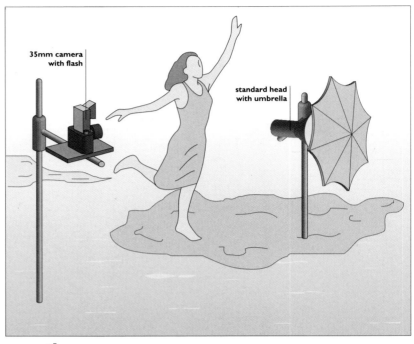

"**I** WANTED A DIFFERENT FEEL FOR THIS" SAYS PHOTOGRAPHER TIM ORDEN. "A CROSS-PROCESSED LOOK WOULD LEND A SURREAL ELEMENT, ADDING TO THE IDEA OF THE WILD AND WACKY ANTICS OF SASHA, MY MODEL."

"It was a bright sunny day and I had my assistant keep the remotely triggered light on the shadow side of the model at all times. As we moved around the scene my assistant ran to stay in position."

Tim used a polarizing filter with Fuji Velvia film rated at 100 ISO, cross-processed it in a C41 negative process, and finally made a print from the resulting negative. Since there was bright sunlight, the shutter speed was determined by the meter reading of the sky. To keep the bright, high-key look, the flash was used to fill on the front of the model's body.

Photographer's comment:

It is necessary to shoot plenty of film when the subject is moving spontaneously.

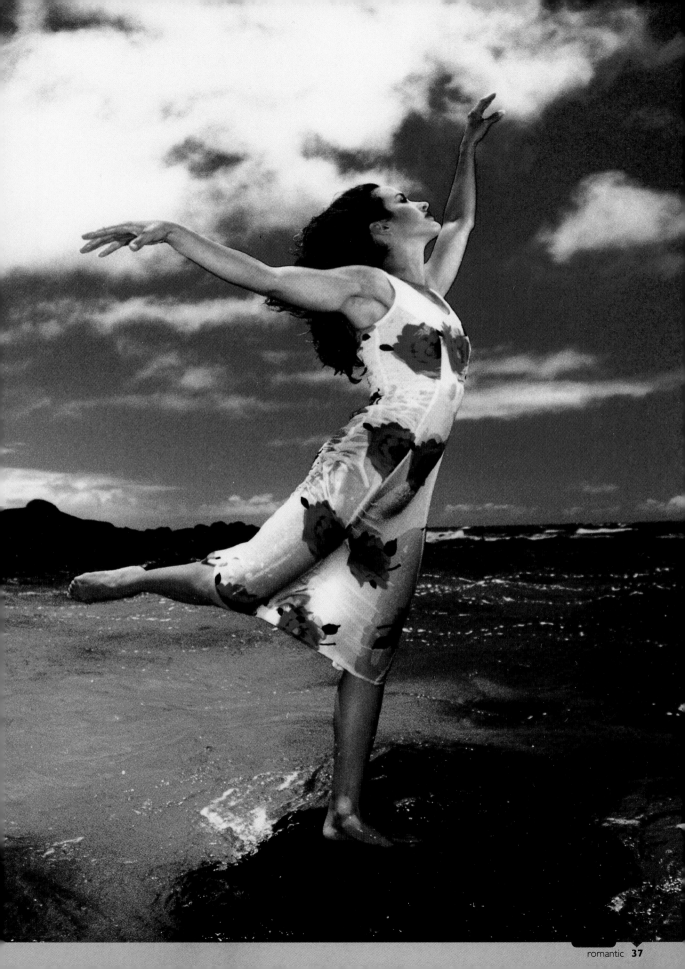

2
body
parts

► The work in this chapter concentrates on details of the human body that turn out to be abstracts, still lifes and colour and tone studies – yet the close-up attention to a part of a body often creates a mood of intimacy that is not generally associated with those other genres.

Exploration of the human form has always been a central concern of artists, and the variety of approaches taken here demonstrate that the fascination has not yet abated. As a disciplined exercise, creating a teasingly abstract image from the most familiar of subjects is a learning experience. The business of the professional photographer is to find a different way of looking at things and to reveal these new insights to the viewer. By concentrating on de-personalized details of the body, the photographers distance themselves from the demands of narrative, or portraiture, or of conveying moods and character – the concerns of most of the images in the other chapters in this book. Instead they free themselves to concentrate purely on form, line, tone, texture and colour – the materials of any abstract artist.

These body studies have an enduring appeal. They can be thought of as a kind of human landscape, with attention drawn to the rise and fall of the geography of the body, where the very nature of the form is central, rather than looking at the owner of the body within a more personalized context. It is no coincidence that several of the shots in the chapter have been used as fine art poster and postcard images: there is always a market for an aesthetically pleasing and interesting new slant on a beautiful human body.

Photographer: **Mark Joye**

Use: **Portfolio**

Model: **Lies**

Camera: **4x5 inch**

Lens: **150mm**

Film: **Not recorded**

Exposure: **1/60 second at f/16**

Lighting: **Electronic flash: 1 soft box**

Plan View

N U D E

▼

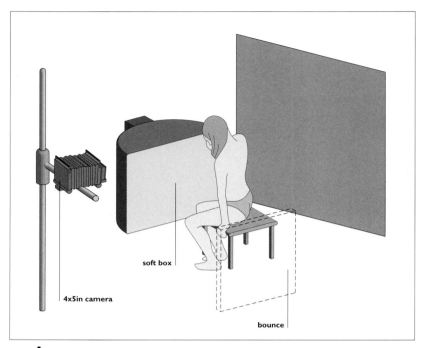

soft box

4x5in camera

bounce

IN THIS PHOTOGRAPH THE POINT OF THE LIGHTING POSE AND FINISHING PAINTING TECHNIQUE ARE AS MUCH ABOUT CONCEALING AS REVEALING THE SUBJECT. ALTHOUGH THE LIGHTING SET-UP SEEMS SIMPLE AND STRAIGHTFORWARD WITH THE SOFT BOX TO CAMERA LEFT AND A REFLECTOR TO THE RIGHT, IN THIS CONTEXT IT PRODUCES AN INTERESTING AND ENIGMATIC IMAGE.

The modestly bowed head, face and near side of the hair, arm and thigh are all discreetly shaded, while the gleaming highlighted areas draw attention to the breasts almost as unrelated abstract shapes. Part of the impact is, of course, from the pose, with the face hidden while much of the body is exposed to view, but the carefully controlled lighting contrast also contributes to the effectiveness of the photo.

The use of liquid light boldly painted on to the paper modifies the potentially classic chiaroscuro effect by adding uneven textures and providing unexpected areas of light and dark.

► It is always worth remembering that less can be more: concealment can be a powerful tool for arousing interest

► For safety's sake, delicately produced images should be transferred on to film before being submitted to clients

Photographer's comment:

The photo has been printed on designer's paper made photosensitive with Fuji Liquid Art Emulsion and toned to sepia.

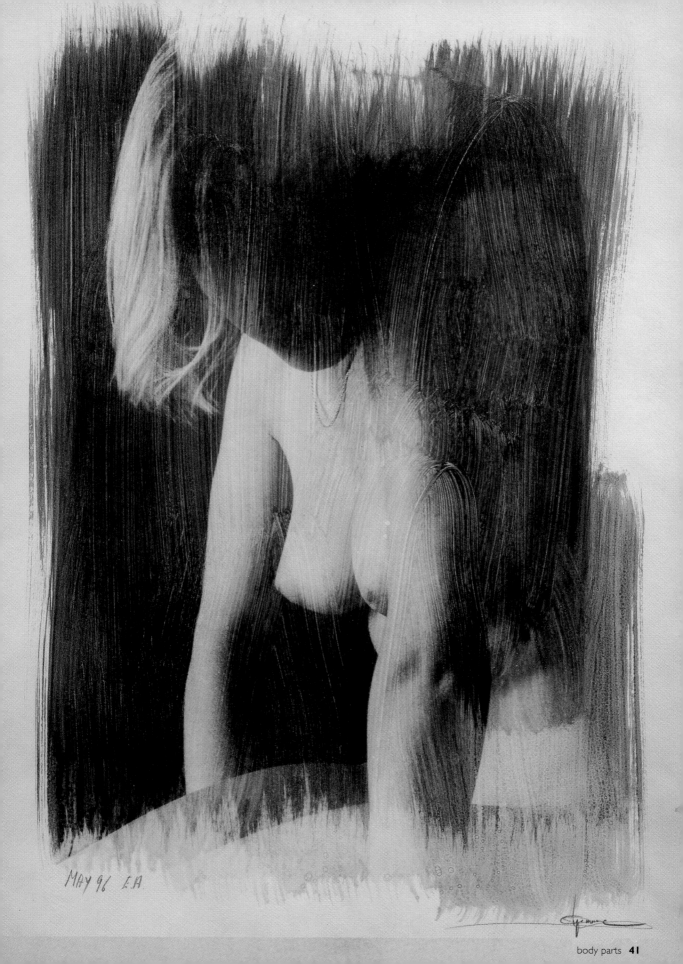

MAY 96 E.A

Photographer: **Patricia Novoa**

Client: **Personal work**

Use: **Portfolio**

Model: **Camila**

Camera: **35mm**

Lens: **80-200mm**

Film: **Kodak infra-red**

Exposure: **f/11**

Lighting: **Electronic flash: 2 soft boxes**

Plan View

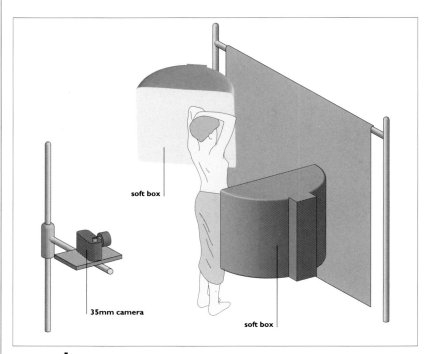

soft box

35mm camera

soft box

INFRA-RED FILM OFTEN PRODUCES A VERY DISTINCTIVE GRAININESS AND CHARACTERISTICALLY LENDS AN ALMOST GHOSTLY, PEARLY GLOW TO SKIN TONES. THIS IS IDEAL FOR CREATING AN OUT-OF-THE-ORDINARY FEEL, WHETHER TO EMPHASIZE TENDERNESS, SOULFUL INNOCENCE OR ETHEREAL SPIRITUALITY, OR TO INTRODUCE A MORE UNNERVING AND UNEARTHLY ELEMENT OF SURREALISM.

► *Infra-red film is normally used with a deep-red filter over the lens, although it is worth experimenting with less intense contrast filters, or even none at all*

► *Infra-red colour film is also available. Its main uses are for medical, aerial and forensic applications, where the colour displacements can make possible the interpretation of otherwise unseen factors*

► *Because of the nature of colour infra-red transparency film, it is an interesting stock to use for artistic purposes*

Here, the delicacy of the model's back is emphasized by the apparent fragility of the image, which breaks up into grains and virtually fades away before the eyes. Two soft boxes only 1m and 1.5m from the model, burn out the skin texture on the areas closest to the lights, while the pearly effect of the infra-red film makes the outer arms seem to glow as if with their own inner light, as though they were the source rather than the recipients of light. Only the hair and areas of slight shading and modelling on the back confirm any sense of the solidity of the subject.

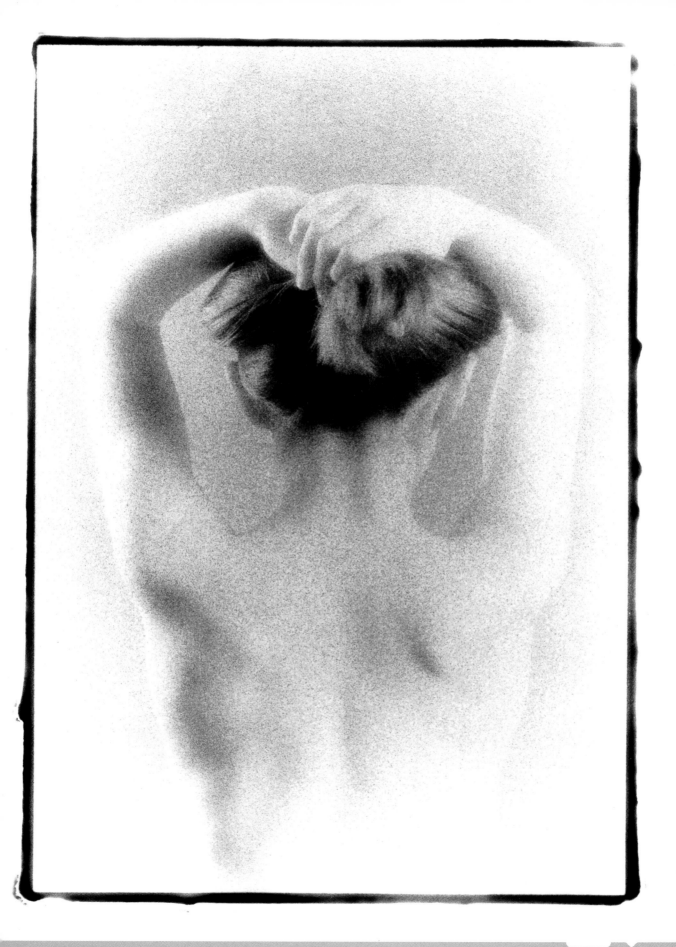

B L O W I N G S K I R T

▼

Photographer: **Gérard de Saint Maxent**

Client: **Personal work**

Use: **Postcard**

Camera: **645**

Lens: **200mm**

Film: **Kodak Tmax 400**

Exposure: **1/60 second at f/11**

Lighting: **Electronic flash**

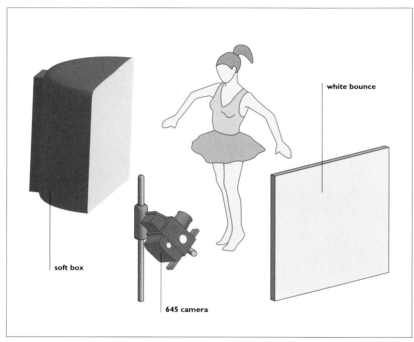

white bounce

soft box

645 camera

THE STRONGLY GRAPHIC SHAPES SEEM INITIALLY QUITE ABSTRACT AND IT TAKES A MOMENT FOR THE EYE TO ORIENTATE ITSELF AND INTERPRET THIS IMAGE. LOOK AGAIN AND THE BLACK AREA MAY TRANSFORM ITSELF INTO THE SILHOUETTE OF AN UPTURNED FACE, OR PERHAPS THE BLACK PROFILE SUGGESTS TO YOU AN AYERS ROCK-LIKE OUTCROP SILHOUETTED AGAINST THE GLEAMING LIGHT OF THE SETTING SUN.

In fact we are, of course, looking upwards at a billowing skirt, a subject reminiscent of the famous Marilyn Monroe image, though in an entirely different style and mood. The abstract quality is all-important here and is achieved by a tight composition lit strongly from above, with absolutely no reflectors or fill coming in from below. The result is bold areas of deep black and flat white and a graphic form that is open to interpretation.

► *This shot was duped on Kodak EPN, which tends to give a cool blue/green to neutral rendition*

► *Lighting from above with rapid fall-off can give an interesting effect*

Plan View

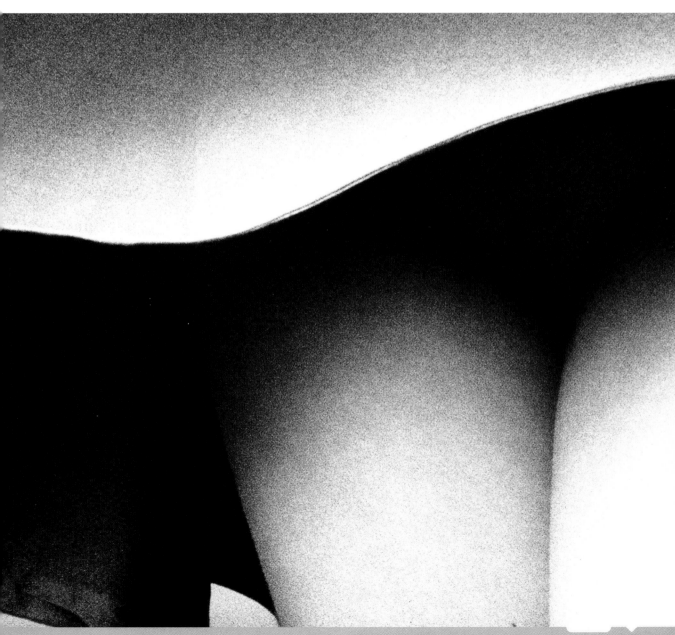

DRAPED NUDE

▼

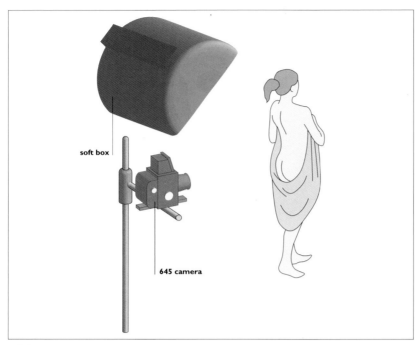

soft box

645 camera

Photographer: **Gérard de Saint Maxent**

Client: **Personal work**

Use: **Postcard**

Camera: **645**

Lens: **200mm**

Film: **Kodak Tmax 400**

Exposure: **1/60 second at f/11**

Lighting: **Electronic flash**

THE ABSTRACT COMPOSITION IS CHARACTERISTIC OF GÉRARD DE SAINT MAXENT'S WORK. COMPARE THIS SHOT WITH HIS "BLOWING SKIRT" ON PAGE 45. THE STYLIZED COMPOSITION IS VERY DISTINCTIVE, BUT NOTICE THE DIFFERENCES IN DETAIL AND LIGHTING AND STYLING BETWEEN THE TWO.

Although the basic concept is similar, the "Blowing Skirt" shot has a distinctly twentieth-century feel: the style of the skirt defines that. But the shot on this page has a much more historical resonance. The drapery and curves are like those of classical statues, with the soft folds of fabric and flesh combined as a single entity. The choice of fabric is important in this respect: the cloth and the skin need to be virtually indistinguishable from one another for the statue imagery to work, with the same even, sculpted, marble-like texture across all areas.

As well as the differences in composition, the differences in lighting are significant. Both shots use a single keylight in the form of a soft box to one side, but for this shot a reflector on the opposite side is also used. This serves the function of adding a slight touch of detail in the deeper areas of the folds of cloth and in the extreme lower-right corner of the frame.

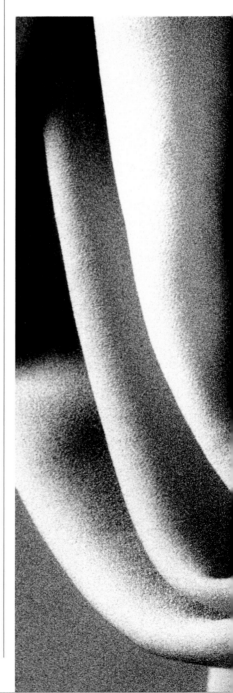

► *Tight lighting ratios are required for higher-contrast films*

► *Black and white can be a good choice when an emphasis primarily on form is required. (Black and white prints can of course be made from colour negatives, if the photographer wishes to shoot in colour to keep his or her options open)*

Plan View

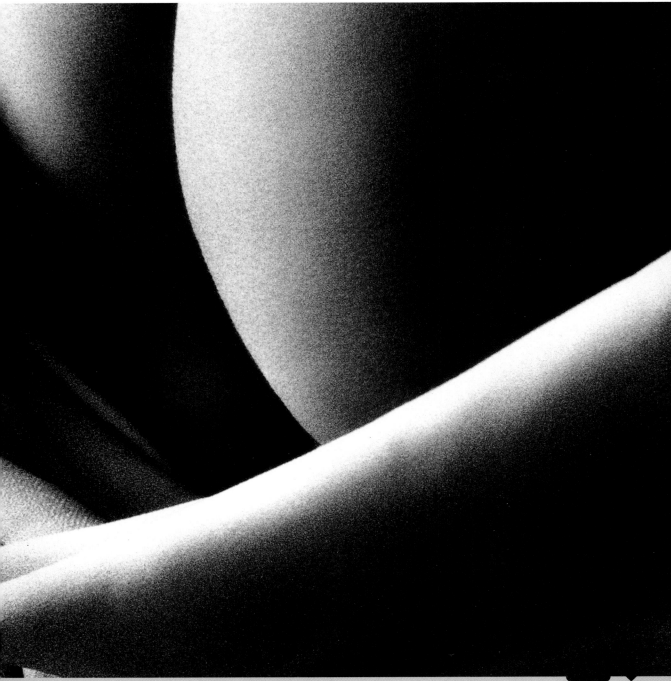

STOMACH

▼

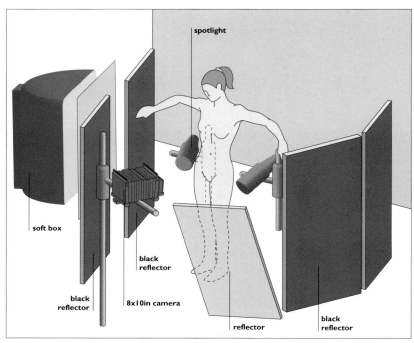

Photographer: **Rob Maclese**

Client: **ICI**

Model: **Claire**

Camera: **8x10 Sinar P**

Lens: **Rodenstock 360mm Sironar N**

Film: **Kodak EPP**

Exposure: **f/22 1/3**

Lighting: **Electronic flash: 3 heads**

Props and set: **Hand-painted mottled background**

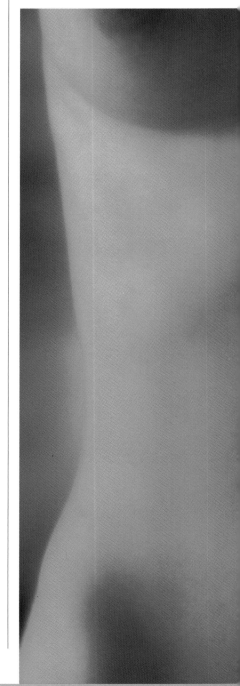

THIS IS A MARVELLOUS EXAMPLE OF HOW AN EXPERT PHOTOGRAPHER CAN COMBINE AN ABSTRACT COMPOSITION WITH A WONDERFUL RICH QUALITY OF LIGHT, TO PRODUCE A SIMPLE BUT STUNNING IMAGE.

The warmth of the skin tone was achieved by using an 81A orange filter in conjunction with an 81C filter and a CC05R filter. Rod Maclese found through experimentation that his first choice, an 81EF, which theoretically has the same Mired value as the 81A + 81C, actually gave slightly too warm a look.

The key light, a soft box to camera left, has a diffusing screen and is also partially flagged by two black panels to control the span of the light falling on the model. Two black reflectors on the opposite side contribute to the fall-off, giving gentle modelling across the model's stomach, with the white reflector supplying some fill.

The pools of light on the mottled painted background give a good sense of separation against the model's torso and are provided by two snooted heads.

Photographer's comment:

Originally this shot was done as a self-promotion piece; however it has since been used by ICI. Also this shot has been re-created in several different forms for various other clients.

► The superb quality of the 8x10-format transparency allows you really to see the detail, even in the shadow areas

► What the theory dictates, for example regarding the laws of colour temperature, is not always matched by what the film records in practice, because of unexpected variables such as thickness of glass

Plan View

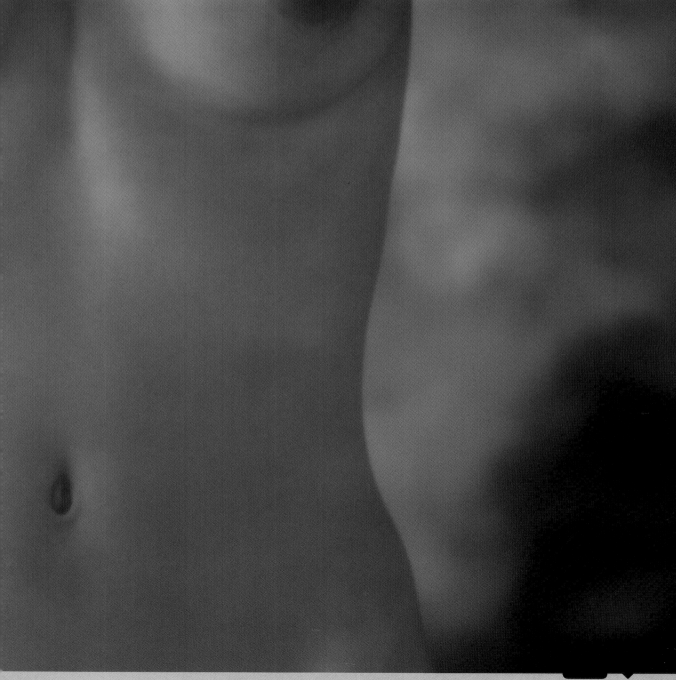

Photographer: **Julia Martinez**

Use: **Personal work**

Model: **Julia Martinez**

Camera: **Canon EOS 5**

Lens: **300mm**

Film: **Tmax 100**

Exposure: **f/22**

Lighting: **Available light**

Props and background: **Location, sea cove in Africa**

Plan View

► *This graphic high-key effect is the result of bright African sunlight and carefully considered printing*

► *Water acts very effectively as a reflector and can also be used to introduce interesting rippling shapes and patterns*

INTIMACY

▼

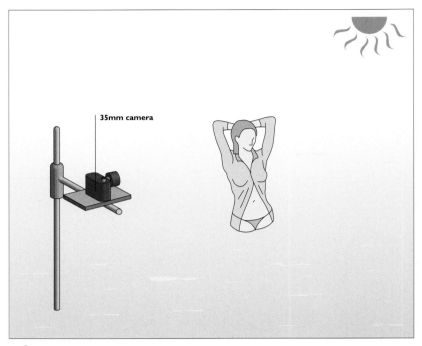

JULIA MARTINEZ WAS STAYING IN AFRICA ON A QUIET BEACH, AND WAS STRUCK BY THE WONDERFUL NATURAL LIGHT OF THE AREA. SHE TRIED IN VAIN TO FIND A MODEL LOCALLY BUT NONE WAS AVAILABLE AND SO, NOT WANTING TO MISS THE SHOT SHE HAD ENVISAGED, SHE DECIDED TO MODEL FOR THE PHOTOGRAPH HERSELF AND TAKE THE SHOT ON SELF-TIMER.

The location was a quiet secluded beach. Julia Martinez set up the camera on a tripod, framing carefully for an identifiable area. She waited for the light to be how she wanted it and then triggered the camera, which was on self-timer, and ran into the water to the correct area. She immersed herself in the sea, and then emerged from the water and positioned herself so that the water would act as a reflector to fill the shadow areas.

The exact framing of the picture had to be attended to later, since the photographer could not see what she had in frame, and so the image was cropped to give the desired composition.

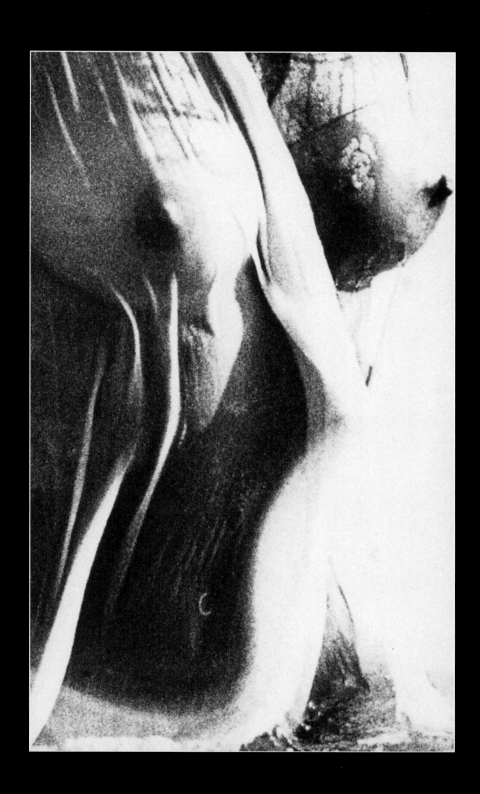

Photographer: **Ron McMillan**

Client: **PBB Agency**

Use: **Brochure cover**

Model: **Emma Noble**

Assistant: **David Grover**

Art director: **Claire**

Camera: **Hasselblad**

Lens: **210mm**

Film: **Ektachrome 100**

Exposure: **f/16**

Lighting: **Electronic flash**

Plan View

BACK PAIN

▼

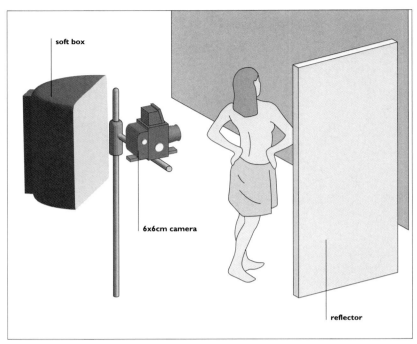

soft box

6x6cm camera

reflector

"**T**HIS IS ONE OF A SERIES OF SHOTS FOR ROYAL COLLEGE OF NURSING INSURANCE SERVICES. THIS ONE IS FOR MEDICAL INSURANCE - FEATURING BACK PAIN PARTICULARLY, AS IT IS COMMON AMONG NURSES," EXPLAINS PHOTOGRAPHER RON MCMILLAN.

"The object of the exercise was to make the shot look 'different' and 'more dramatic' than usual. We shot on transparency film but processed it in C41 negative chemicals. The resulting negatives are more contrasty and the colour balance is affected. From the negatives, prints were made altering the colour balance even more, plus adding a grain screen in the enlarger to achieve the end result. A great deal of experimenting was necessary to produce a final image that satisfied everyone concerned, since one of the problems with this kind of exercise is that you can create a wide variety of quite different results from the same original shot."

► *It is better to shoot the image "clean" without filtration, since various types of manipulation can then be tried out at the printing stage*

► *To avoid too stark a final image when cross-processing, it is important to have a very tight lighting ratio*

Photographer's comment:

Photographers must be careful not to make the original film too contrasty, as the cross-processing, etc. will increase the contrast anyway, so a fairly softly-lit original is required.

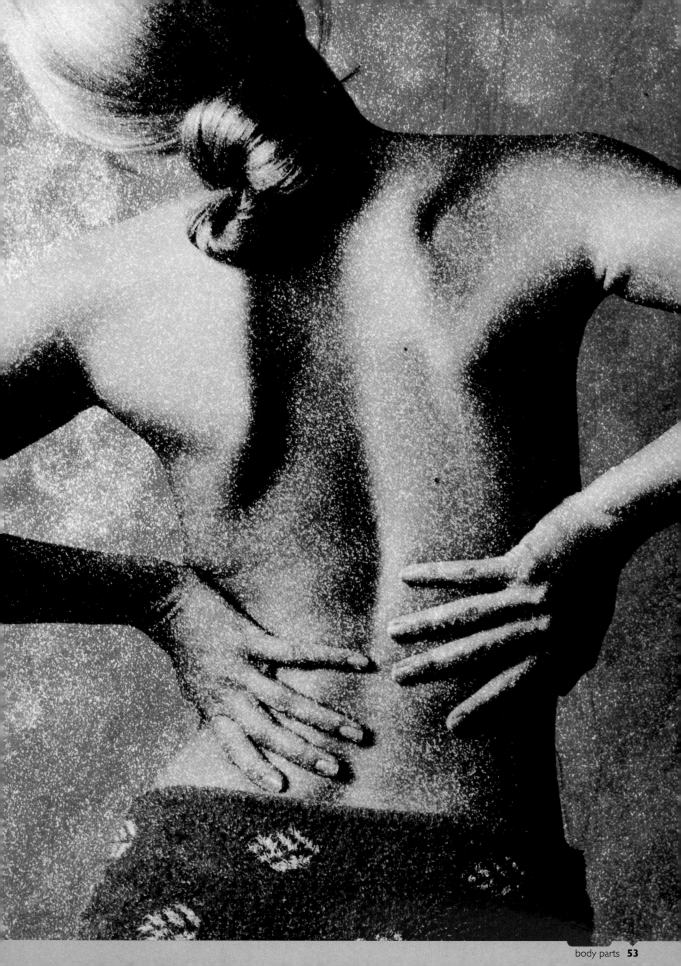

Photographer: **Frank Wartenberg**

Client: ***Stern* Magazine**

Use: **Editorial *Stern* Cover**

Assistant: **Bert**

Art director: **Frankie Backer**

Camera: **Mamiya RZ67**

Lens: **185mm**

Film: **Agfa 25**

Exposure: **Not recorded**

Lighting: **Electronic flash: 5 heads**

Props and background: **Grey backdrop material, box to sit on**

Plan View

N U D E

▼

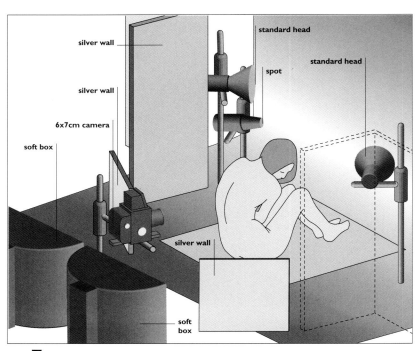

THIS IS A SUPERB EXAMPLE OF HOW SOMETHING SEEN CLEARLY IN ITS ENTIRETY CAN SIMULTANEOUSLY LOOK LIKE AN ABSTRACT. IT IS OBVIOUS THAT THIS PICTURE IS A BACK VIEW OF A NUDE, BUT WITH CAREFUL POSING OF THE MODEL, STYLING OF THE HAIR AND SYMPATHETIC USE OF LIGHTING, A PLAIN NUDE SHOT HAS BEEN MADE INTO BOTH A CLASSICAL STUDY AND A SPLENDID ABSTRACT WORK OF ART.

Two large soft boxes some distance behind and above the camera give a blanket of soft light, which is in turn reflected off the model's back and hair, giving skilfully crafted highlights, complementing these sculpturally perfect features of the body. Two silver reflectors, one either side of the camera and at the same proximity, brighten the highlights even further. The hair is styled to display an array of alternating tones.

Compositionally, the considered fashioning of the coiffure and position of the head and the upper part of the body create an extraordinary, abstract effect.

The two standard heads on the background are supplemented by a spot to the left, which gives a pool of slightly brighter light to ensure separation. Finally, notice how the positioning of the model gives a deliberate low-light rim down the left side of the torso.

► *Even the most familiar subject can be given an abstract form*

► *Abstract presentation of a familiar form reveals new qualities and a new way of looking at things for the viewer*

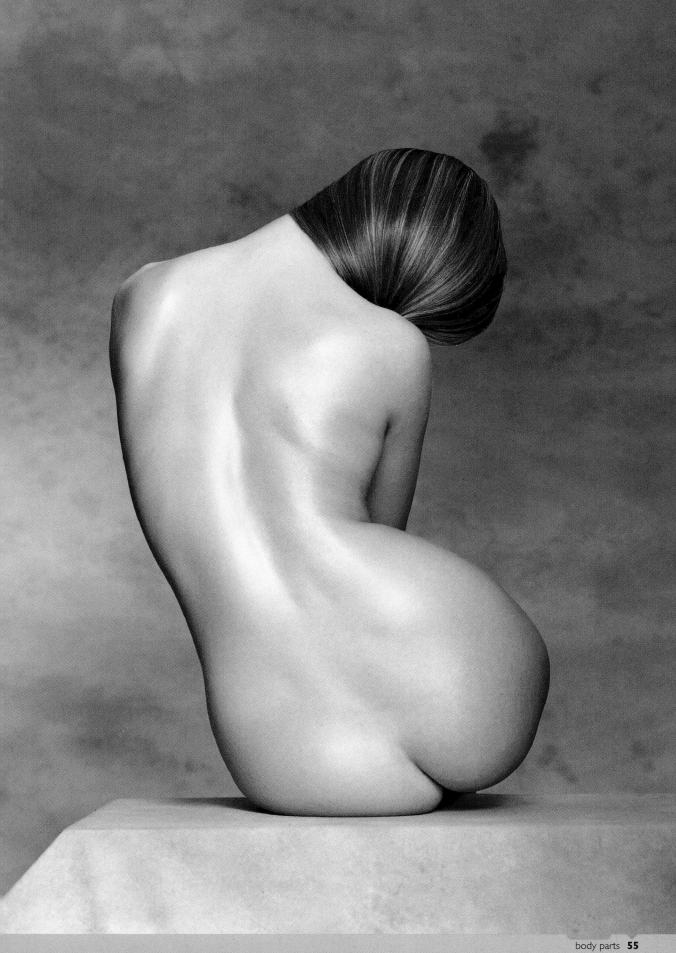

3

costume

It is something of a truism that the concealed is infinitely more tantalizing than the revealed, but it is a principle that is amply demonstrated by the shots in this chapter. Costume is a major part of the allure and scene-setting of these photographs, and the expert styling and choice of model-dressing demonstrates the sheer power that these elements have and the range of moods that the clothing can create. From innocence to up-front sensuality, the choice of dress, whether a simple sheet as in Ben Lagunas's and Alex Kuri's "Brinco Advertising" (page 73), or the elaborate lingerie trappings of Frank Wartenberg's "Gabriella and dog" (page 75), sets the parameters for the impact of the shot.

The costume works closely in this respect in conjunction with the styling and lighting to establish the tone and mood. Light (or the lack of it) can be a form of dress in itself: see Ben Lagunas's and Alex Kuri's "Moda Kit" (page 63), for example, where the model is dressed in little more than a shadow, to great effect. A glamorous look can be achieved with or without conventionally "glamorous" clothing. While for some, stockings and suspenders are *de rigeur* for a glamour clothing shot, other shots in this chapter show the allure of the other end of the scale too. Nothing could be more innocent than a bride in white (Holly Stewart's "1920s Wedding Hat", pages 68-69), but the equally sensual quality of the virginal image is indisputable.

Photographer: **Frank Wartenberg**

Use: **Cover/advertising**

Camera: **Nikon F4**

Lens: **105mm**

Film: **Kodak EPR**

Exposure: **1/60 second at f/4**

Lighting: **Electronic flash: 5 heads**

Props and background: **White paper background**

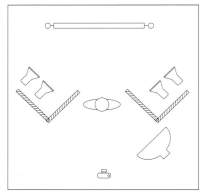

Plan View

▼

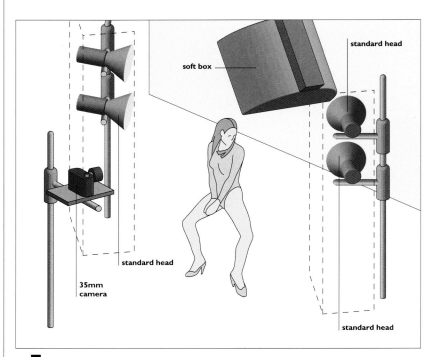

soft box

standard head

standard head

35mm camera

standard head

standard head

THIS STARTLING SHOT MAKES GOOD USE OF ALL THE FACTORS AVAILABLE. THE MODEL'S BODY IS PROVOCATIVELY POSED, THE COSTUME GIVES INTERESTING PLAYS OF LIGHT AGAINST HER FORM, THE PROPS (BLACK BEADS) ARE USED TO ADD ANOTHER SHOCK ELEMENT IN TERMS OF CREATING A BONDAGE LOOK AND ADD VISUAL INTEREST BY ADDING PINPRICK HIGHLIGHTS, THE COLOUR IS BOLD AND GRAPHIC, AND THE STRONG LIGHTING IS STARK AND VOYEURISTIC.

Much of the starkness of the image derives from the fact that the model is set almost like a cut-out against the high-key background, with not a hint or trace of shadow behind. Because the model is on a podium with the soft box angled down at her, and she is some distance from the background, any shadow is likely to fall on the floor and not on the white backdrop. The fact that there are four standard heads directed at the background also contribute to ensuring that no shadow will be visible, as they would burn out any stray unwanted shadow.

► *The positioning of the two pairs of black panels effectively make a tunnel, giving good fall-off at the sides of the model*

Photographer's comment:

The girl is standing on a podium 40cm high.

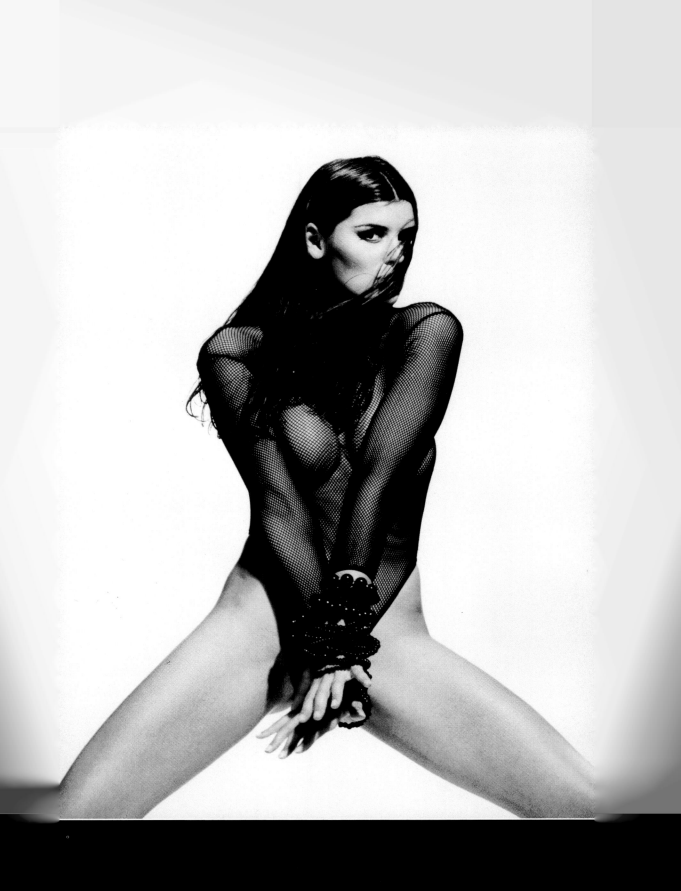

Photographer: **Tim Orden**

Use: **Personal work**

Model: **Kiana**

Assistant: **Donna Orden**

Camera: **35mm**

Lens: **80-200mm**

Film: **Fuji Provia 100 ISO**

Exposure: **1/60 second at f/4**

Lighting: **Available light, on-camera flash**

Props and background: **Beach, Hawaii**

Plan View

► *Time spent observing natural rhythms can pay off when it is necessary to foresee a moment*

► *A flash unit with a fast recharge is essential when taking shots in quick succession*

K I A N A

▼

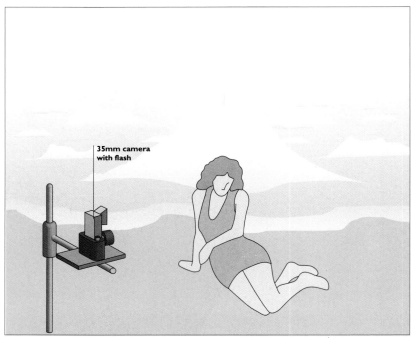

35mm camera with flash

"My photos are a combination of a statement about people and place. As I look back on the images I'm often struck by the fact that I realize, Yeah, I was there." That feeling doesn't come from working in a studio.

"Maui has so many photo opportunities. Everything from snow to desert scrub, green mountain pastures and thick tropical jungles. Lava fields to white sandy beaches. I'm never at a loss for a location setting. Bringing my knowledge of light to the outdoor environment began the really interesting work of my life."

It is easy to see from the superb setting and richness of the environment in this shot why Tim Orden is so inspired by Hawaii. The almost-too-perfect sunset gives the ideal backdrop. To avoid silhouette occurring against the bright sky and ensure detail on the front of the model, an on-camera flash is used, sending more light on to the model's face and the front of her body. The crashing waves behind are lit by ambient light only and provide a background for the model almost exactly echoing her pose; evidence of a watchful eye and expert timing on the part of the photographer.

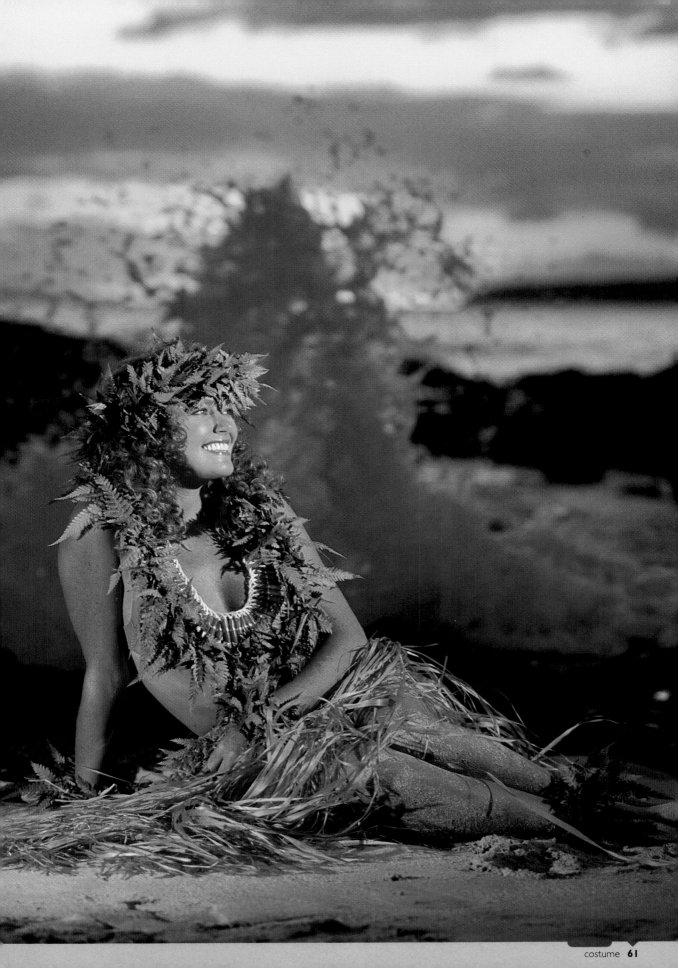

Photographer: **Ben Lagunas and Alex Kuri**

Client: **Arouesty Asociados**

Use: **Advertising campaign for Moda Kit**

Assistants: **Patricia and Gabrielle**

Art director: **Carlos Arouesty**

Stylist: **Elvia Orrco**

Camera: **6x6cm Hasselblad 205TCC**

Lens: **180mm CF Sonnar**

Film: **Kodak Tmax 100**

Exposure: **1/125 second at f/16**

Lighting: **Electronic flash: 1 soft box**

Plan View

► *It may be necessary to build-in space around the subject, depending on how the image is to be used. Shooting and supplying a full frame image does not always mean filling the available frame with the subject*

► *The discipline of having to think creatively within the specific parameters of a brief can be inspiring and even liberating for the photographer, to find something that works for both the photographer and the client*

► *Even when using plain black as a background, there are endless materials, textures, types of reflectivity and finishes to choose from. As with any other background it is important to know what you want*

M O D A K I T

▼

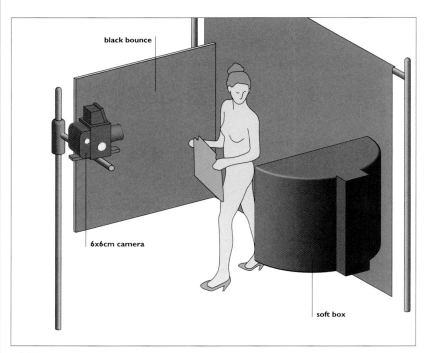

WHEN PRODUCING IMAGES FOR ADVERTISING, PHOTOGRAPHERS OFTEN NEED TO BUILD-IN AREAS WITHIN THE COMPOSITION SUITABLE FOR ACCOMMODATING WHATEVER TEXT MIGHT BE ADDED LATER. THE LARGE, DARK, EVEN AREAS THAT FRAME THIS SHOT ARE IDEAL FOR THIS PURPOSE AND ALSO ALLOW THE CLIENTS THE FLEXIBILITY TO CROP THE IMAGE IN DIFFERENT WAYS FOR DIFFERENT USES WITHIN THEIR CAMPAIGN.

The soft box lights the outline of the nude and enough of the product for identification. The black bounce prevents any accidental fill from reflecting-in, ensuring both the smooth blackness of the background and side, and the essential modest shading of the model.

The dramatic, graphic image achieved is striking, attractive, provocatively sensual yet tastefully discreet. It also puts across the product strongly and is a practical, flexible image for advertising purposes. In other words, it fits the client's brief exactly.

Photographer's comment:

The product is in the bag - inexpensive clothes. This was an original and controversial campaign. We had to show nudes, but not as pin-ups or pornography. We don't want to offend the buyers. The art director looked for an intimate but unusual moment. He loves the final result - the light modelling of the body.

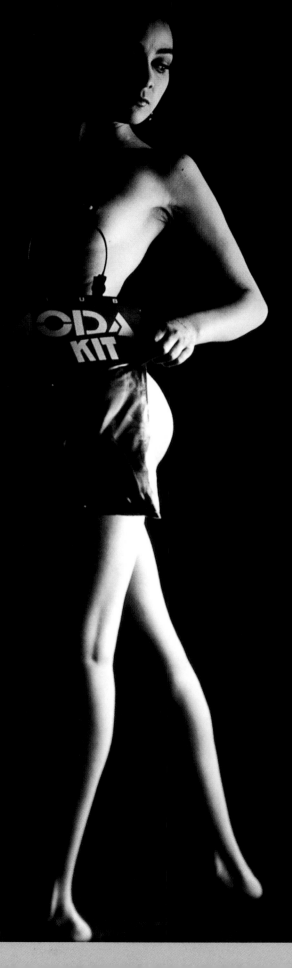

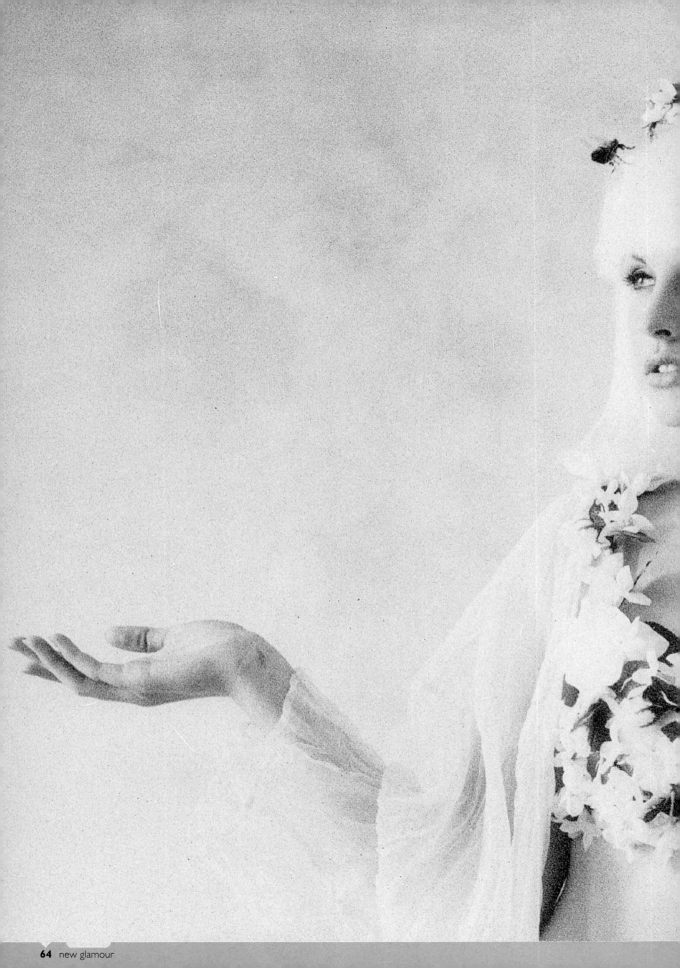

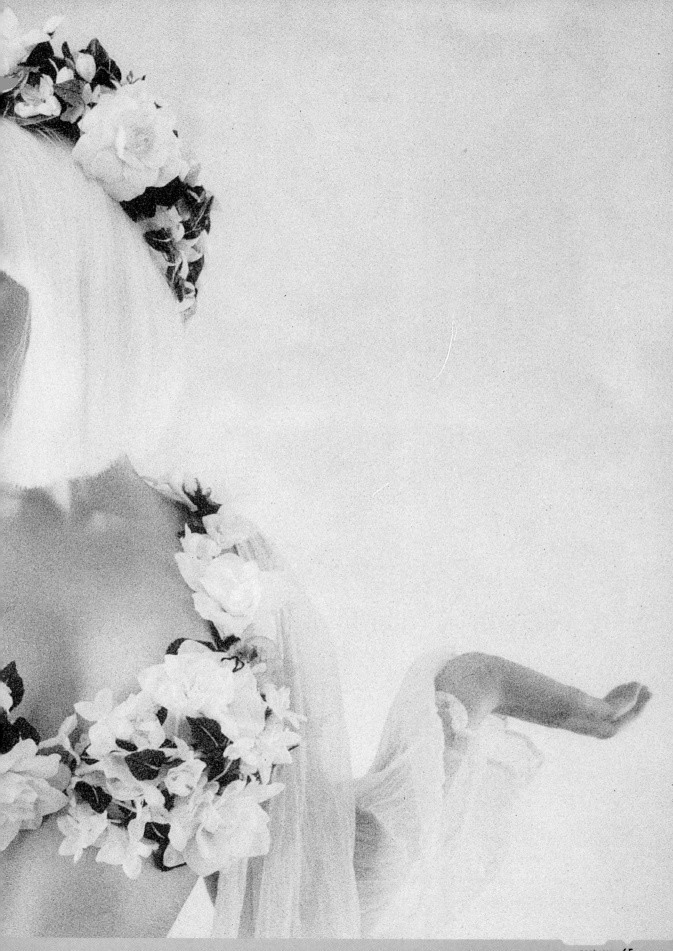

Photographer: **Holly Stewart**

Client: **Self-promotion**

Use: **Book**

Model: **Cindra**

Make-up: **Dawn Sutti**

Stylist and hair: **Victor Hutching**

Camera: **6x6cm**

Lens: **140mm**

Film: **Tmax 100**

Exposure: **1/125 second at f/11**

Lighting: **Electronic flash**

Props and background: **Painted background**

Plan View

► *A versatile lighting set-up can give substantially different results with different subjects*

► *The best models have excellent control over their every feature and can give just the expression and mood that is wanted - as long as the directing is good*

F L O W E R H A T

▼

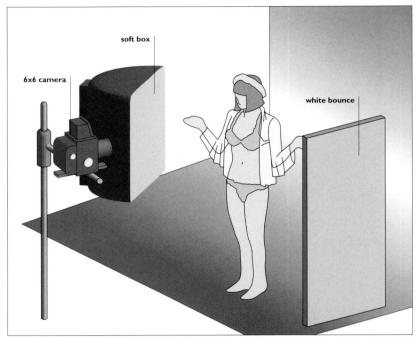

COMPARE THIS SHOT WITH HOLLY STEWART'S "1920s WEDDING HAT", SHOT ON PAGE 69. THE SAME MODEL WAS USED IN BOTH IMAGES, BUT THE FEEL IS COMPLETELY DIFFERENT. DIFFERENT STYLING, MAKE-UP AND HAIR, CLOTHING AND PROPS AND DIFFERENT CHOICE OF FILM, PROCESSING AND FINISHING CREATE TOTALLY DISSIMILAR MOODS AND "PERIOD" LOOKS. THESE SHOTS ALSO DEMONSTRATE, OF COURSE, THE SHEER VERSATILITY OF THE MODEL.

What is surprising is that the one other factor (apart from the model used) that has not changed between the two shots is the lighting set-up, yet the result is quite startlingly different. This is to do with the nature of the subject that the light falls on. Whereas the light in the bride shot had yards of white fabric to play on, in this shot there is a busily-textured costume, smooth coiffure and expanses of bare skin in place of material. The sheen on the torso gives a strong sense of modelling, while the gleam on the hair has the opposite effect, flattening out the shape to exaggerate its stark brilliance.

The eyes are clear and sparkling, with a well-defined catch-light; a dark-eyed model would not have given the same effect. The openness and freshness of the pose, expression and costume are poles apart from the slightly closed-in pose and mood of shy modesty of the bridal image.

Photographer: **Holly Stewart**

Client: **Self-promotion**

Use: **Editorial**

Model: **Cindra**

Hair and styling: **Victor Hutching**

Make-up: **Dawn Sutti**

Camera: **6x6cm**

Lens: **140mm**

Film: **Kodak EPZ**

Exposure: **1/125 second at f/8**

Lighting: **Electronic flash**

Props and background: **Painted background**

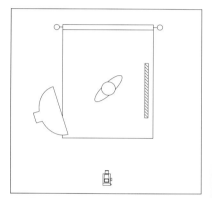

Plan View

1 9 2 0 s W E D D I N G H A T

▼

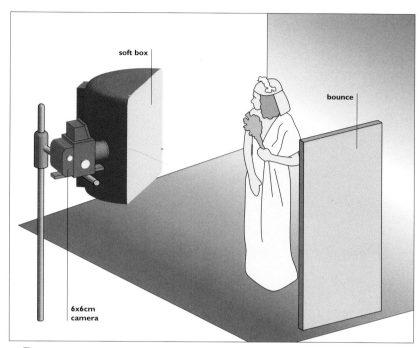

DIFFERENT LIGHTING ON DIFFERENT AREAS OF A SHOT CAN BE ACHIEVED BY SPECIFICALLY LIGHTING EACH INDIVIDUAL AREA SEPARATELY OR, MORE ECONOMICALLY, IT CAN BE MANAGED BY USING A VERSATILE SET-UP IN CONJUNCTION WITH EXPERT POSITIONING OF THE MODEL. EACH PART OF THIS SHOT HAS UNIQUE LIGHTING CONDITIONS, YET ALL WAS ACHIEVED WITH A SINGLE SOFT BOX AND A WHITE CARD REFLECTOR.

► *The motivation for the picture is the 1920s-style wedding hat, so the styling of the shot picks up on both the bridal theme to place it in context and on the period, using appropriate make-up, posing and clothing*

► *Even in a high-key picture there can be areas of maximum black*

The lighting on the dress and on the model's left arm is considerably different from that on her face and right arm; and the lighting on the roses is different again.

The expanse of white fabric is lit for a radiant high-key look by a soft box only 1m from the model to camera left and an 8x4-foot white fill card even closer on her other side. As a result the clothing is almost equally bright on the key and fill sides. The model's face, throat and right arm, however, are lit only by the soft box, directional because of its proximity, since they are tilted away from the white card, so little fill light bounces on to them. The result is a greater modelling effect with definite light/shade sides to these areas of the body. Most of the hair to the right is shaded from the reflected light by the position of the fabric veil, which has the effect of diffusing the bounced light on this area of hair, as well as providing some shade. Finally, the roses are held in front of the model and thus pick up highlights from both the soft box and the bounce, giving a busy texture to contrast with the floating swathes of fabric.

This detail shows a section of the shot where several adjacent areas, each with entirely individual and different lighting conditions, meet. The stray golden ringlet is one of the brightest highlights in the whole shot, and is in full light from the soft box; yet it is right next to a cluster of shadowy hair positioned just out of reach of the same light source, registering as almost the darkest area of the shot. Somehow, this shadowy hair rests upon a dazzling, brightly lit area of clothing, and this in turn lies against a shaded part of the throat. The roses in the foreground display both light and shade.

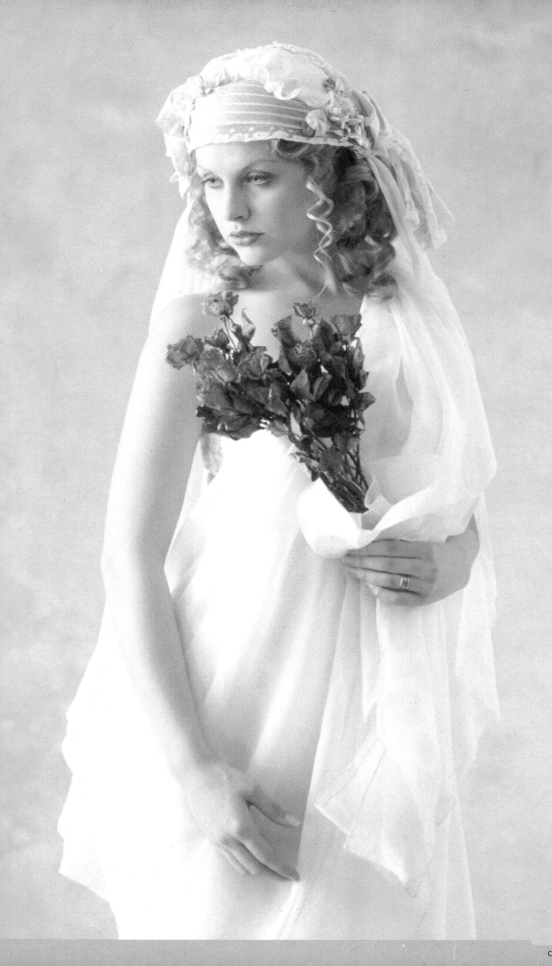

Photographer: **Terry Ryan**

Client: **Couture**

Use: **Point of sale and packs**

Model: **Helen**

Assistant: **Nicolas Hawke**

Make-up: **Alli Williams**

Camera: **6x6cm**

Lens: **120mm macro**

Film: **Kodak Ektachrome 100 Plus**

Exposure: **f/22**

Lighting: **Electronic flash: 3 heads**

Props and background: **Large cotton backdrop**

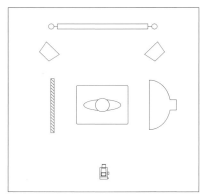

Plan View

► *Directional lighting helps to differentiate areas of a subject when that subject consists largely of white against white, but careful exposure control is required*

► *With a uniformly-coloured subject, details such as the hair colour of the model become tremendously important to lend contrast and "substance" to the shot*

H E L E N

▼

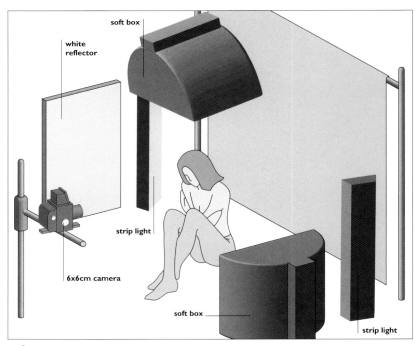

Since this is a product pack-shot image, it is essential that the tights should be foremost in the final image. The graphic qualities of the pose draw attention to the product effectively, and the high-key look is a subtle way of emphasizing the smoothness of the hosiery.

The swimming pool light to camera right gives evenly distributed light over the whole subject, but the pose provides contrasting areas of relative shade on the upper part of the legs, though the shot is basically a low-contrast image – the reflector to the left and choice of colour of the product, background and model's skin tones combine to ensure this.

The hair, the only area of remarkably different tone, is lit separately from above by an overhead soft box. This gives tremendous detail and texture to the coiffure.

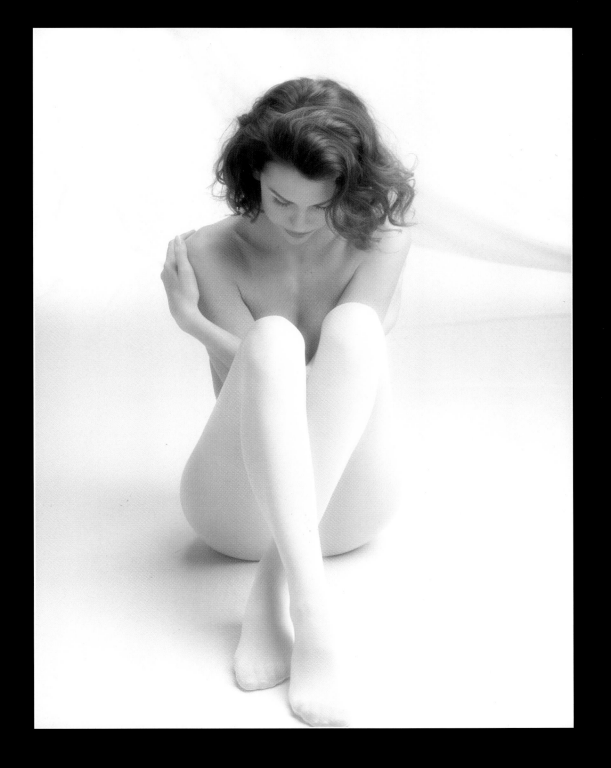

Photographer: **Ben Lagunas and Alex Kuri**

Client: **Entreteias Brinco**

Use: **Advertising**

Model: **Jacqueline Robinson**

Assistants: **Suzanne, Natasha, Victoria**

Art director: **Cory Rice**

Stylist: **Elvia Orozco**

Camera: **Sinar 4x5 inch**

Lens: **Schneider 180mm**

Film: **Kodak Tmax**

Exposure: **1/60 second at f/8**

Lighting: **Electronic flash**

Props and background: **The model was covered by the product, Buckram**

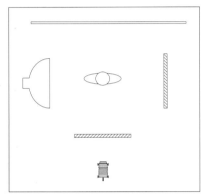

Plan View

► *The qualities of the product that come across from an image should be the qualities that the client wants to emphasize, and this, in turn, will dictate the quality of light that is required*

► *When balancing varying amounts of light to deliberately "burn out" selective areas of the shot, it is essential to know how the film stock will react to the relative light intensities used, and to expose accordingly*

"BRINCO" ADVERTISING

▼

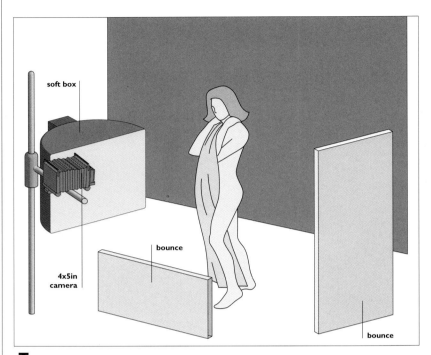

THE PRODUCT ON DISPLAY IS THE MATERIAL COVERING THE MODEL, SO THAT HAS TO BE THE MAIN FOCUS OF ATTENTION – AND OF LIGHTING – IN THE SHOT. THE MODEL IS IN EFFECT A LIVING PIECE OF APPARATUS, USED TO HOLD AND DISPLAY THE FABRIC AND TO ADD INTEREST TO WHAT IS BASICALLY A PRODUCT SHOT.

Everything shines out from the picture centre. The 2m-square soft box to the left and two reflectors provide bright light on the fabric itself, while the positioning of the material gives some shadows on the model's body. The bounce to the front is directed on to the material rather than the model, and the relative darkness of her face and arms give some detail, in contrast with the glowing white areas. Even the light falling on the background (which is spill light from the soft box plus the bounce on the right) gives a sense of radiation out from the centre of the material.

The composition owes more to Botticelli's "Birth of Venus" than it does to a typical pack shot, however. Just as in the famous painting Venus rises from the waves and modestly clutches her long hair partially to hide her nakedness, her head inclined away from the viewer's gaze, so the model here discreetly holds the material to herself, revealing only the tantalizing extremes of her curves, and averts her eyes from the camera.

Photographer's comment:

The light on the front enhances the product. The back light shows the model's silhouette.

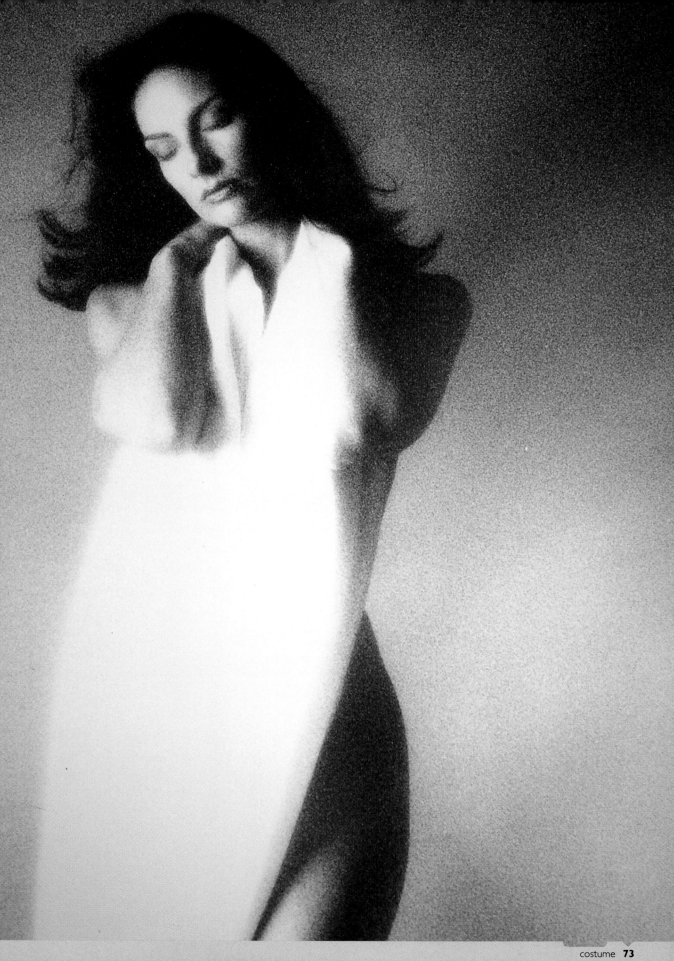

Photographer: **Frank Wartenberg**

Client: **Self-promotion**

Use: **Portfolio**

Model: **Gabriella**

Assistant: **Bert Spangemacher**

Stylist: **Uta Sorst**

Camera: **Mamiya RZ67**

Lens: **110mm**

Film: **Kodak EPR 64**

Exposure: **Not recorded**

Lighting: **Electronic ring flash**

Props and background: **Golden painted wall and ground**

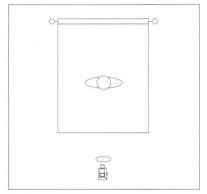

Plan View

► *Note the difference in resulting colour between the gold-painted area that is facing the light directly (i.e. the wall), and that lying at 90 degrees to it (i.e. the floor)*

► *The orange 81A warm-up filter used here deepens the skin tones*

G A B R I E L L A A N D D O G

▼

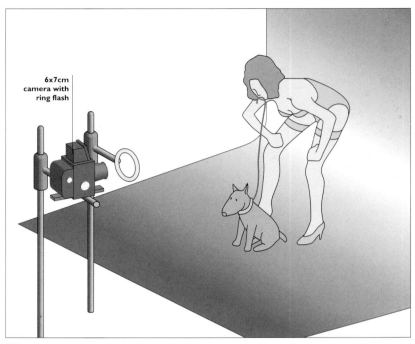

6x7cm camera with ring flash

THE CHOICE AND POSITIONING OF THE ELECTRONIC RING FLASH IS CRUCIAL. IT IS SET DIRECTLY FACE-ON TO THE MODEL AND THE DOG, AND IS LARGE ENOUGH TO BURN OUT THE GOLD BACKGROUND OVER A LARGE AREA.

The resulting catch-lights in the eyes are a compelling aspect of the shot. The eyes of the dog have a fiendish, unearthly glint, echoed by the shine on the nose and the studs of the collar, and the piercing pin-pricks of red in the eyes of the model are a small but significant detail in defining the mood of the shot. The pose ensures that the faces of the model and of the dog are equidistant from the camera, so that the plane of focus is exactly the same for both pairs of eyes.

The flash simultaneously back lights the shot, inasmuch as it is reflected by the gold paint on the wall, giving interesting shadow-cum-reflections on the floor, though the depth of field reduces the separation that might otherwise be expected; there is little or no rim-light defining the edge of the model, but instead, fine but dark fall-off shadow areas that "ink in" her outline.

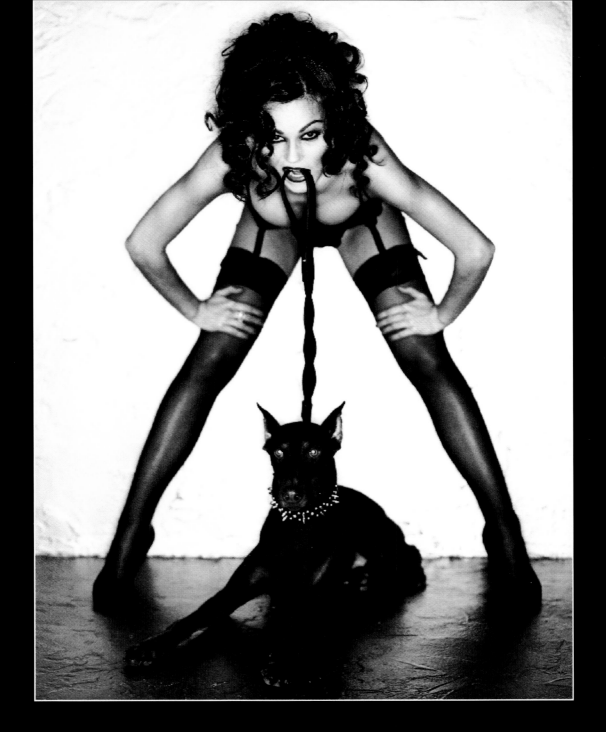

4

men

The place of glamorous men in advertising markets is now well established and is indeed a growth area. This is largely because the commercial world has in recent years brought out a multitude of products aimed specifically at men, from cosmetics such as skin care products to perfume and even fashion underwear. Even the traditional male products such as shaving items and hair cream have taken on a much more explicitly glamour feel: it is now "hip" and cool for men to be beautiful. As a result of so much male-based glamour advertising, men and women alike have now become more used to seeing and enjoying the male form as an object of beauty in itself.

Apart from the enormous range of advertising images of men that are now commonplace, there is also a large market in male glamour pin-up type shots, aimed at the mass postcard and poster-buying public. These are commonly presented as artistic, moody shots, often in black and white or monochrome to emphasize the graphic qualities of the rippling torsos and strong jawlines of the archetypal male model; a trend that the shots in this chapter reflect.

At the other end of the "artistic shot" spectrum is fine art work that is destined for the art gallery rather than for mass-production. This category of endeavour is represented here by a detail from a major work by Wolfgang Freithof, an ambitious piece of work-in-progress based on a classic Hieronymus Bosch painting.

Photographer: **Frank Wartenberg**

Client: *Foto Magazine*

Use: **Cover**

Model: **Kirk Smith**

Assistant: **Bert**

Stylist: **Ruth Vale**

Camera: **Mamiya RZ67**

Lens: **110mm**

Film: **Kodak EPR 64**

Exposure: **Not recorded**

Lighting: **Electronic ring flash plus 1 head**

Props and background: **Golden wall**

Plan View

GOLDEN MAN

▼

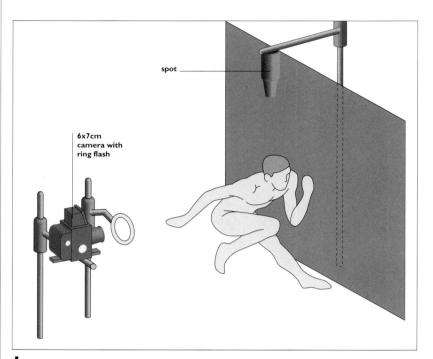

spot

6x7cm
camera with
ring flash

IT IS NOT OFTEN THAT THE SUBSIDIARY LIGHT IN A SET-UP IS ACTUALLY OF MORE IMPORTANCE THAN THE MAIN KEYLIGHT. BUT IN THIS EXTRAORDINARY SHOT, THERE IS LITTLE TO SAY ABOUT THE STRAIGHTFORWARD KEY LIGHT, A SPOT THAT IS SIMPLY PLACED OVERHEAD TO GIVE DIRECTIONAL DOWN-LIGHTING. INSTEAD, IT IS FRANK WARTENBERG'S SUBTLE USE OF A FILL-IN RING FLASH THAT COMMANDS MORE ATTENTION AND CREATES THE MAIN AREAS OF INTEREST.

Interestingly, the purpose of the front ring flash here is not to provide light so much as to provide shadow. Behind the hands and outstretched arm in particular it throws a slim shadow on the background, which creates both an amount of separation and a sense of movement.

The positioning of the ring-flash, lower than the model and pointing up at him, means that the legs throw further shadow areas on to the torso and the bent arm, adding to the high-contrast film noir (or perhaps we should say "film d'or") look.

► *Choice of background is a key part of a picture. Here the texture creates highlights in the upper part, and lowlights in the lower part of the image*

► *A shutter speed of 1/125 second or less is essential for freezing a moving subject*

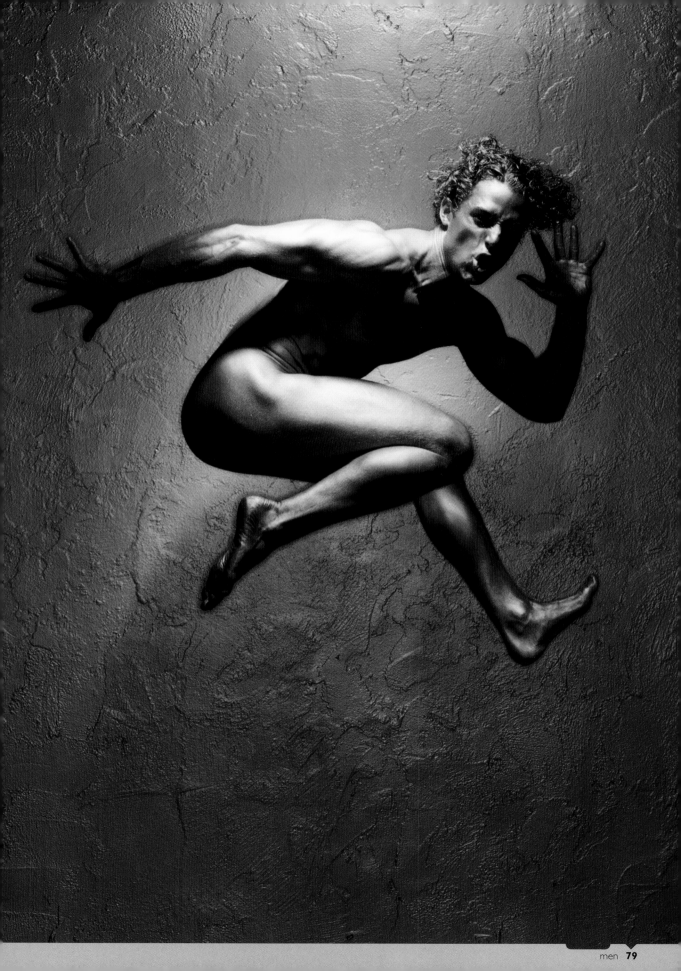

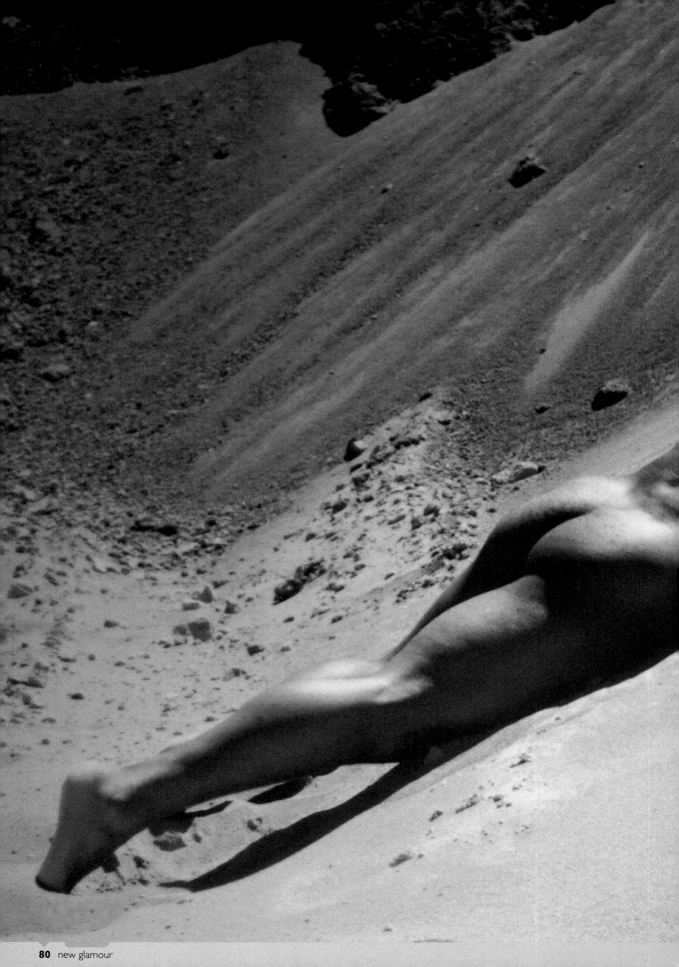

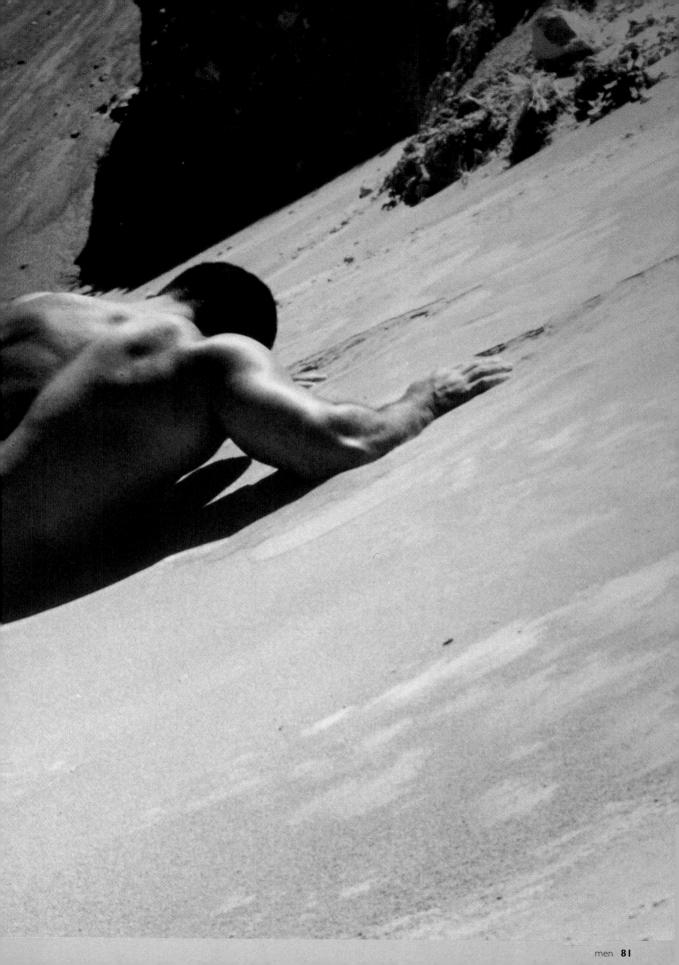

Photographer: **Ben Lagunas and Alex Kuri**

Use: **Fine art personal work**

Assistant: **Natasha, Victoria, Suzanne**

Art director: **Ben Lagunas**

Stylist: **Charle**

Camera: **Mamiya RZ67**

Lens: **250mm**

Film: **Tmax 100**

Exposure: **1/60 second at f/16**

Lighting: **Available light**

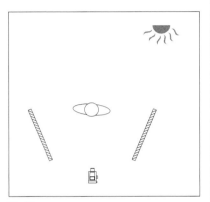

Plan View

SKIN TO SKIN COLLECTION I

▼

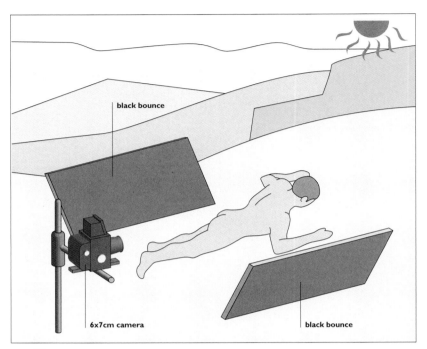

THE MODEL IS LYING IN A BARREN SANDY LANDSCAPE. THE GREEN FILTER MAKES THE YELLOW SAND AREAS JUST IN FRONT OF THE MODEL RECORD AS LIGHT GREY, WHILE THE SHADIER AREAS, WHICH TO THE EYE WOULD HAVE HAD A MORE ORANGE APPEARANCE, RECORD AS DARKER GREY.

The impression created is of a high key pool of apparent light in front of the model, emphasizing the power of the blazing sun beating down on both the desert landscape and on the model's back. The use of black panels gives just adequate fill on the near side of the body.

► *Black and white contrast filters pass light of their own colour*

► *It is important to take account of the fact that deeply coloured contrast filters absorb a great deal of light and are best used in bright conditions*

Photographer: **Myk Semenytsh**

Use: **Calendar**

Model: **Graham Gardner**

Art director: **Paul Thompson**

Agency: **Opus Advertising**

Camera: **RB67**

Lens: **180mm**

Film: **Fuji RDP**

Exposure: **2 seconds at f/11**

Lighting: **Electronic flash: 2 soft boxes plus tungsten projector**

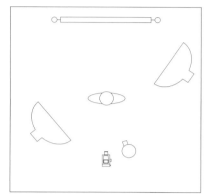

Plan View

► *Using a focused tungsten-based projector in conjunction with an electronic flash gives a defined area with a relatively yellow/warm orange cast*

► *Projections onto a model's body can be used to achieve a surreal effect fairly simply*

CALENDAR SHOT

▼

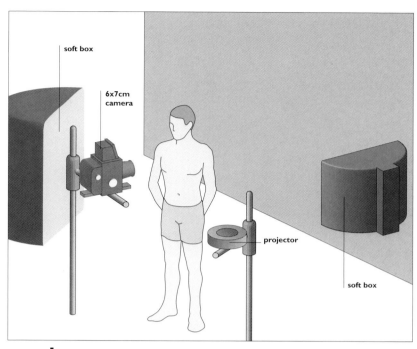

soft box

6x7cm camera

projector

soft box

IT TAKES A MOMENT FOR THE EYE TO ADJUST AND REALISE THAT THE IMAGE ON THE CHEST IS A PROJECTION OF A SLIDE ONTO THE TORSO.

The low-key background is lit by a soft box which sends sidelong light onto the backdrop. The main lighting on the model is from a larger soft box to the side of the model which gives bright light on the nearside surfaces of his body and allowing much gentler ambient light just to lift slightly the farside surfaces. It is these relatively unlit areas which then receive the majority of the projection (with a tungsten source).

Notice the careful posing of the model to make the most of the well-defined physique in terms of the composition. The vein on the arm to the right defines the exact point on the curvature of the arm where the light and shade areas meet. The angle of the jaw lines gives a similar result. Elsewhere, the curvature of the torso adds the rippling effect of the projection.

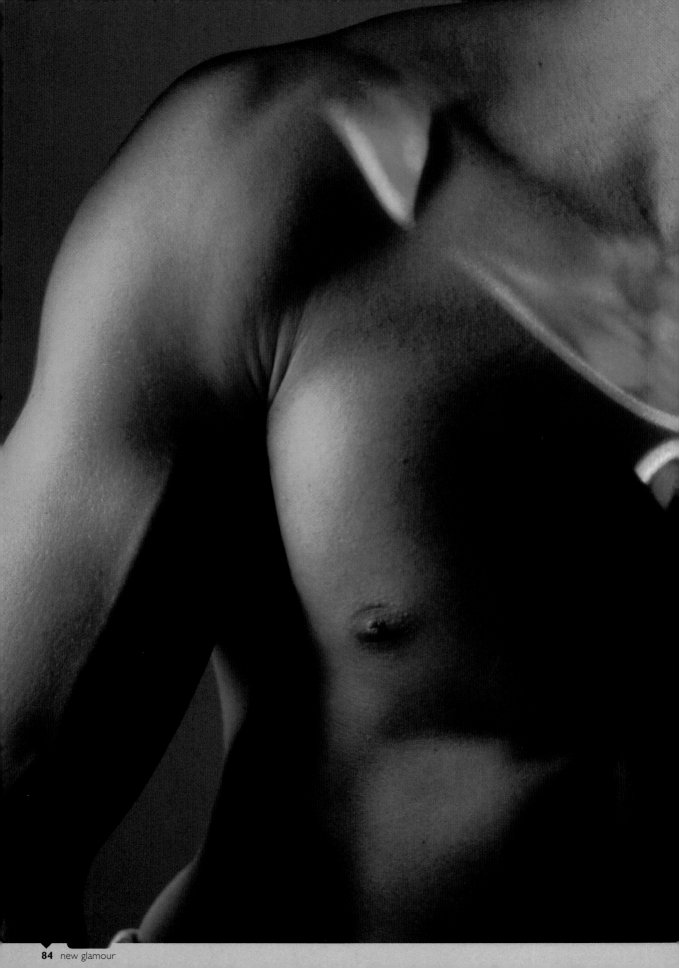

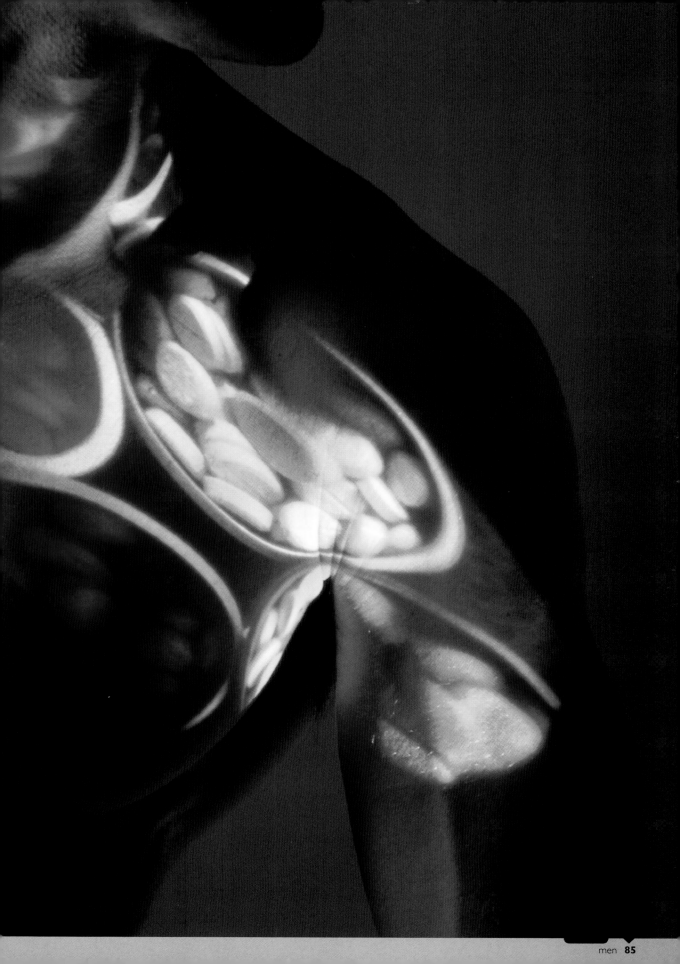

Photographer: **Wolfgang Freithof**

Client: **Personal work**

Use: **Gallery exhibition**

Model: **Ben**

Art director: **Brian Kenet**

Painter and collaborator: **Miriam Kenet**

Camera: **6x6cm**

Lens: **80mm and 150mm**

Film: **Kodak Tri-X 400**

Exposure: **1/125 second at f/5.6**

Lighting: **Electronic flash**

Props and background: **Neutral canvas backdrop unlit for separation of the subject.**

Plan View

Strawberry Plan View

► *With a multiple-image collage, consistency of lighting is a major consideration*

S T R A W B E R R Y M A N O P A R T

▼

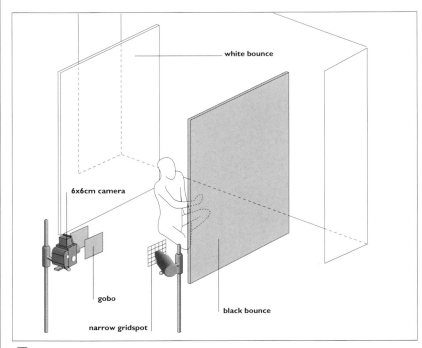

white bounce

6x6cm camera

gobo

narrow gridspot

black bounce

THIS SHOT REPRESENTS A SMALL DETAIL FROM AN AMBITIOUS PIECE OF "WORK-IN-PROGRESS", WHICH WOLFGANG FREITHOF IS HOPING TO COMPLETE BY THE YEAR 2000. THE FINISHED ARTWORK WILL CONSIST OF A PHOTO-COLLAGE TRIPTYCH WITH A 2M-SQUARE CENTRAL PANEL AND TWO 2x1M EDGE PANELS, AND WILL INCLUDE APPROXIMATELY 800 NUDE FIGURES BASED ON THE PAINTING, "GARDEN OF EARTHLY DELIGHTS", BY HIERONYMUS BOSCH.

The collage will include many clusters of figures assembled around a central item. The items range from the strawberry in this case to other fruits, vegetables and animals. A different model has been shot in multiple poses for each central item, and all poses are modelled after the painting. Although the shooting part of the project is complete, the assembly will obviously take a considerable time.

For each one of the poses in this detail, the model was placed between a white and a black panel, against an unlit canvas backdrop and lit by bounced light originating from a source with a narrow grid spot to camera right. The aim was to give distinct but not harsh shadows. The black panel on the right gave a strong fall-off ratio.

The strawberry was side-lit by a single soft box and the component parts of the image were assembled physically on an op-art backdrop specially commissioned for the project.

Photographer's comment

Sponsorship welcome!

Photographer: **Salvio Parisi**

Client: **Cesare Paciotti Belts**

Use: **Editorial**

Model: **Luca Zecca**

Assistant: **Chicca Fusco**

Hair and make-up: **Anna Alliata**

Art director: **A. Caramenti**

Camera: **4x5 inch**

Lens: **150mm**

Film: **Kodak Ektachrome 100 Plus**

Exposure: **1/30 second at f/8 1/2**

Lighting: **Tungsten and electronic flash**

Plan View

L U C A

▼

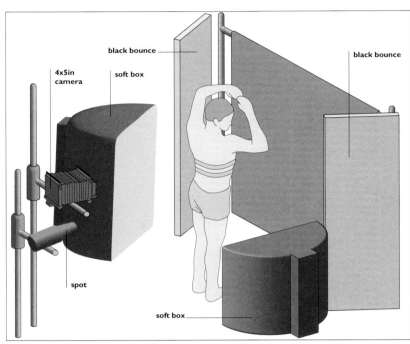

black bounce

4x5in camera

soft box

black bounce

spot

soft box

"THIS PICTURE BELONGS TO A SERIES OF DRESSED/NON-DRESSED FASHION ACCESSORIES: THAT'S THE REASON FOR THE UNUSUAL WAY OF WEARING BELTS!", EXPLAINS SALVIO PARISI.

The two soft boxes, one on either side (180 × 120cm on the left and 100cm-square on the right) give a diffuse tungsten light on the whole of the model's back; the photographer is only using the modelling light. The focusing spot set to a small square shape is directed at the belts only. Because Salvio Parisi has used daylight-balanced film with the tungsten soft boxes, the overall quality of light is very amber. The focusing spot is a flash, so it records as correctly balanced bright light in contrast with the golden ambience of the rest of the image. The photographer has exposed for the dark brown belts within the flashlit area, thus over-exposing the paler skin tone in the rest of the square.

► Mixing flash and tungsten light is an option worth keeping in mind for certain effects

► A high degree of control in shaping the beam of the light source can be achieved by using either a gobo or a focusing spot with shutters

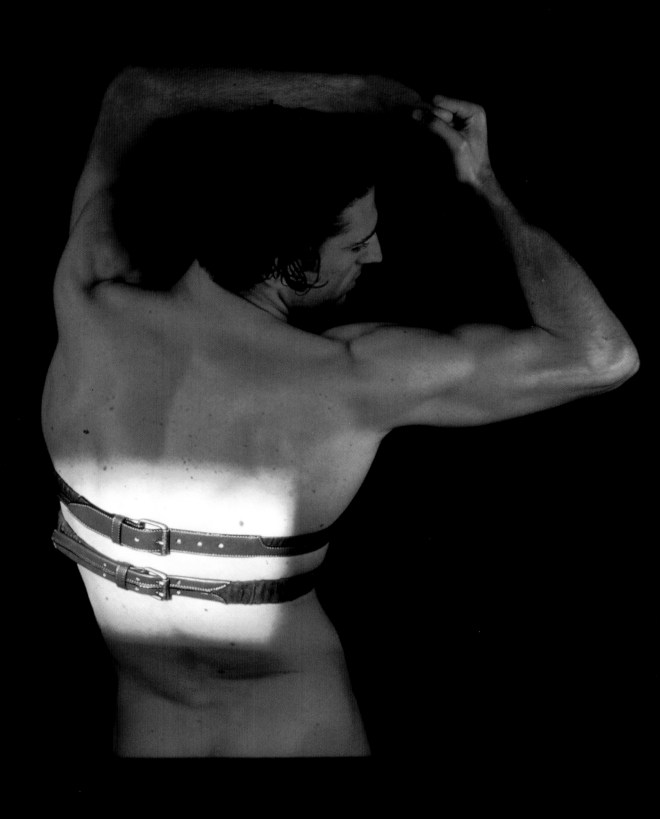

Photographer: **Frank Wartenberg**

Use: **Presentation/underwear**

Model: **Nic**

Assistant: **Jan**

Stylist: **Laurent, Uta**

Camera: **Nikon F4**

Lens: **105mm**

Film: **Polaroid Polagraph**

Lighting: **Available light plus reflector**

Props and background: **Grey background**

Plan View

UNDERWEAR PRESENTATION

▼

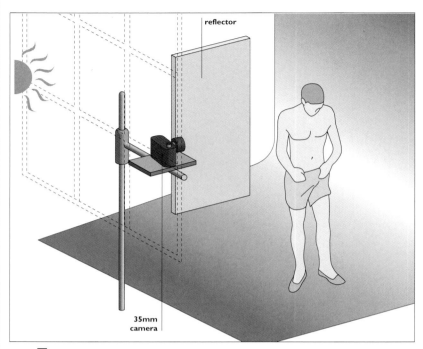

THIS IS AN ARCHETYPAL IMAGE OF MALE BEAUTY. IT WAS USED IN AN ADVERTISING
CONTEXT TO PROMOTE UNDERWEAR AND WAS THUS TARGETED PARTLY AT THE
POTENTIAL MALE CONSUMER, BUT ALSO, OF COURSE, AT THE MEN'S
UNDERWEAR-BUYING FEMALE PARTNER CONTINGENT.

The appeal therefore has to be double-edged. On the one hand, it is important that men should be able to relate to the image personally; to create a desire for them to purchase the product on display. At the same time it must appeal to women, who may well be the purchasers of gifts for partners, and the glamour and eroticism of the shot have an important function in this respect.

The contextualizing is therefore an important aspect of the image's capacity to compel the viewer. The model is lit by a reflector, which bounces daylight from a window on to the body, giving more directionality and intensity to the ambient available light. The sunny aspect lends an air of romanticized idealism to the shot, without undermining the masculinity of the image. This essential quality is assured by the choice of idealized model and the strong, graphic styling.

► *Daylight can be controlled to a certain extent by the use of bounces and flags*

Photographer: **Ben Lagunas and Alex Kuri**

Use: **Fine art personal work**

Assistants: **Natasha, Victoria, Suzanne**

Art director: **Ben Lagunas**

Stylist: **Charle**

Camera: **Mamiya RZ67**

Lens: **250mm**

Film: **Kodak Tmax 100**

Exposure: **1/30 second at f/16**

Lighting: **Available light**

Plan View

SKIN TO SKIN COLLECTION II

▼

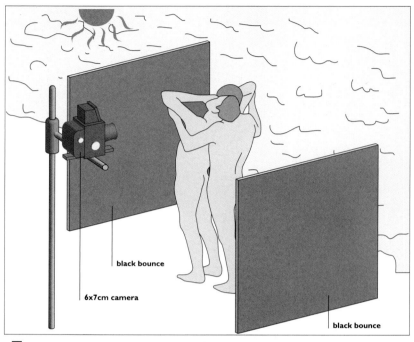

black bounce

6x7cm camera

black bounce

THE BACKGROUND FOR THIS OUTDOOR SHOT CONSISTS OF TREES AND GRASS, SO A GREEN FILTER WAS USED TO LIFT THESE AREAS, LIGHTEN THE FOLIAGE AND PROVIDE MORE DETAIL.

The models are positioned between two black panels and natural bright sunshine is the only source of light. The result is a tunnel of darkness with very strong overhead lighting - the panels ensure that absolutely no reflected fill can bounce in from the sides.

The long lens used from a distance of about 6m means that the bodies of the entwined models fill the frame almost completely. The shine from the sunlight on their bodies emphasizes their form exquisitely.

► *Careful positioning of black panels can substantially increase the directionality of available light*

Photographer: **Tim Orden**

Use: **Personal work**

Model: **Augustus**

Assistant: **Donna Orden**

Camera: **35mm**

Lens: **60mm**

Film: **Kodak Tri-X rated at 100 ISO**

Exposure: **Not recorded**

Lighting: **Available light, reflector**

Props and background: **Sandy beach, Hawaii, gourd pot**

Plan View

▶ *On an overcast day a reflector can distort the impression of where the sun (the true main light source) is*

▶ *Down-rating a film, combined with pull-processing, will generally give more shadow detail*

A U G U S T U S A S A N C I E N T H A W A I I A N

▼

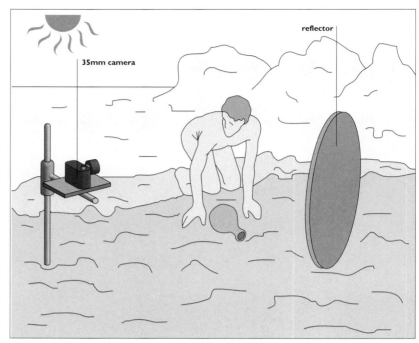

"**N**UDE SHOTS CAN SOMETIMES BE AWKWARD IF ANY MEMBER OF THE TEAM IS ILL AT EASE," TIM ORDEN COMMENTS.

"Shooting dudes without clothing is easy for me – like being at an outdoor locker room. If it weren't for my wife helping me, the situation would have been without shame. As it was, Augustus was shy about being totally exposed with my wife, Donna, around. It was Donna's job to do the make-up and help with the reflector. So, I convinced my model that we might as well just 'get on with it' and 'Do what we're trying to do.'

"Donna showed no outward signs of titillation by Augustus's walking around nude. The shoot went on and all was well. During a break, Donna went over by the shoreline and sat down. She seemed distraught. I asked her, 'Are you okay?' Her answer was, 'Yeah, I'm just a little hot.' 'What do you mean, hot?', I blurted. 'Well, what do you *think* I mean?' I guess she was looking cooler during the shoot than she actually was."

There are no additional lights in this shot, just a 1-metre-square silver reflector on the shadow side of the model. The photographer used a 400 ISO film rated at 100 ISO and under-developed the result by 2 stops.

Photographer's comment:

I had Augustus roll in the sand to give him a body texture.

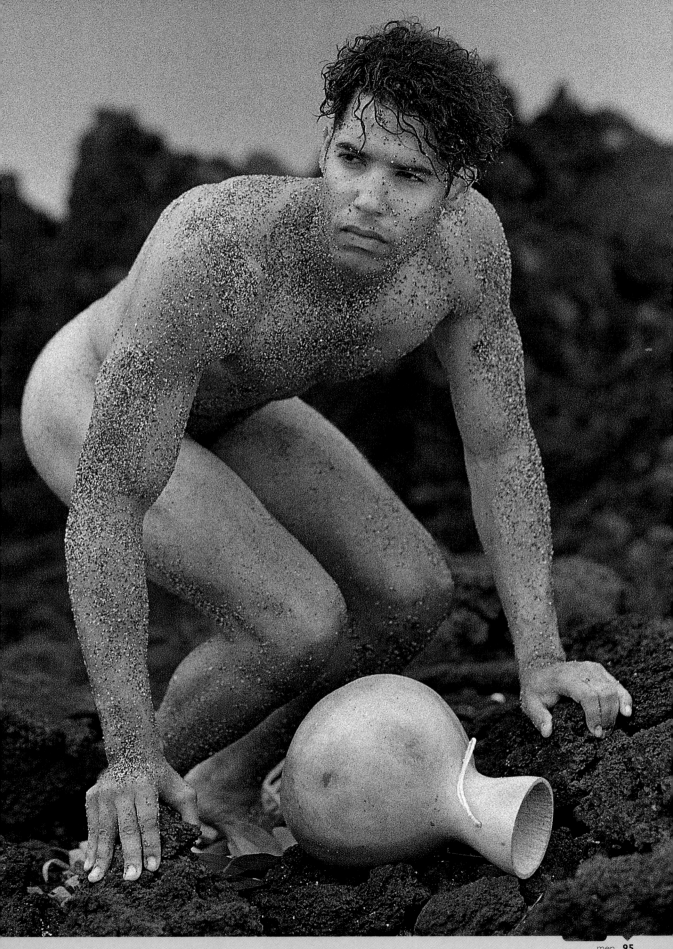

Photographer: **Julia Martinez**

Model: **Rosari**

Camera: **MF Mamiya 645**

Lens: **300mm**

Film: **Tmax 400**

Exposure: **f/11**

Lighting: **Available light**

Plan View

R O S A R I

▼

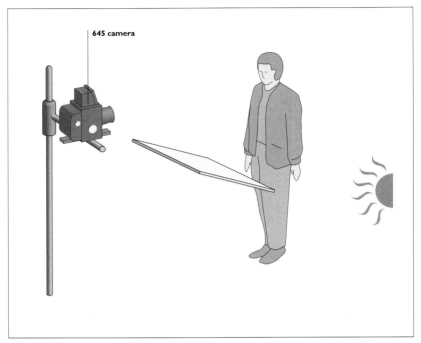

645 camera

WITH JUST THE SIMPLEST OF LIGHTING — LATE AFTERNOON SPANISH SUN —
AND SOME IMAGINATIVE FINISHING EXPERIMENTATION, JULIA MARTINEZ
HAS PRODUCED A FASCINATING IMAGE.

Perhaps "icon" would be a better term. The religious resonances are obvious, from the centrally-placed crucifix pendant and ghostly Turin shroud effect, to the very pose, features and expression of the model, which recall many a depiction of Jesus Christ, or, perhaps, of Saint Sebastian, with torso exposed and vulnerable.

There is little to say about the lighting except that although the model was positioned side-on to the sun, the immediate impression is not that of strongly directional side lighting. This is because the bounce, strategically placed, evens out the lighting on the body.

More unusual is the unconventional textile-like finish and obscuring texture of the picture. This was achieved at the printing stage by projecting through an overlay of tissue paper, which accounts for the woven-fibre quality of the image. Finally, hand colouring with crayons completed the post-production.

The final unexpected twist is that despite the overwhelmingly male resonances, the model is actually a woman.

► *A wide range of different grades of tissue paper is available, from coarser, disposable paper handkerchiefs to the finest craft paper*

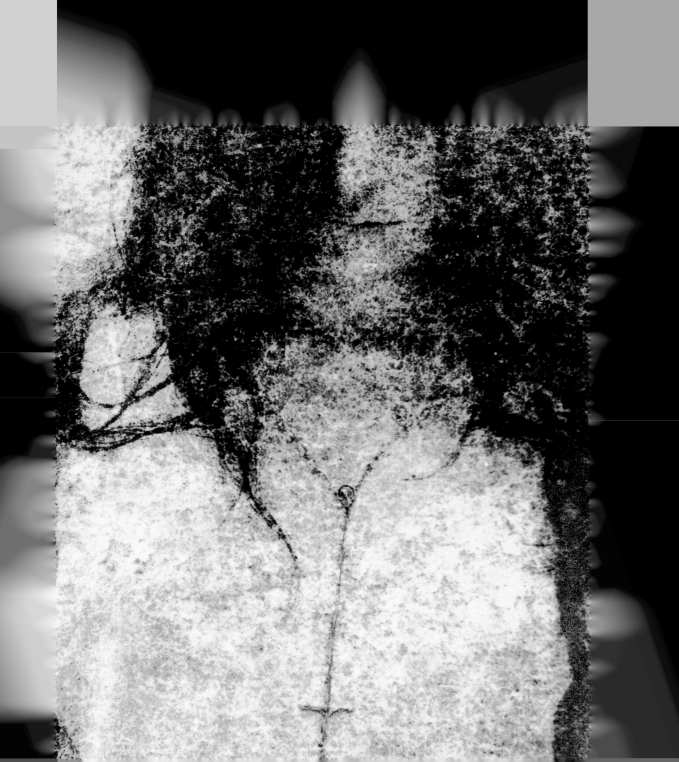

5
settings

Of the eight shots in this chapter, about half are shot on location and half are studio-built settings. What is common to them all is the fact that the setting is an integral part of the motivation of the shots. For some shots the setting implies an element of story-telling or narrative to the picture: what is this person doing here? What's happening in this scene? For others, the connection of the setting with the model is more to do with aesthetic qualities and contrasts of texture, form and so on. Another possibility is that the setting provides a context without making any overtly narrative point, but makes sense of a subject that would be oddly disembodied without an appropriate context.

A studio setting doesn't have to be expensive, elaborate or detailed to be effective. Even just a minimal hint of the appropriate props can set the scene firmly; for example in "Gym" (page 113) there is little more than a well-positioned punch bag in the shadowy background, which gives just enough context in which to place the subject.

It is not always down to the photographer to decide whether a set or a location will be used, or what the details of the set should be. What is down to the photographer is to compose the frame and light its contents appropriately.

Photographer: **Frank Wartenberg**

Client: *Brigitte* **Magazine**

Use: **Editorial**

Assistant: **Jan**

Camera: **Nikon F4**

Lens: **105mm**

Film: **Polaroid Polagraph**

Exposure: **Not recorded**

Lighting: **HMI spot**

Props and background: **Artist's studio (location)**

Plan View

L I N G E R I E

▼

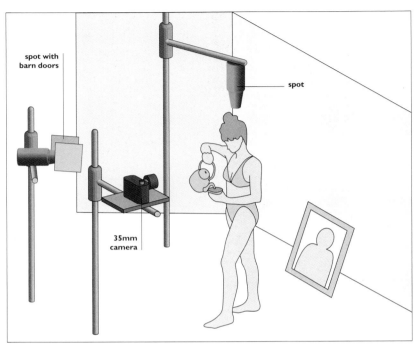

THE LIGHTING IN THIS SHOT IS DUAL-PURPOSE. IT ESTABLISHES A TIME OF DAY AND THUS CONTRIBUTES TO THE NARRATIVE IMPLICIT IN THE SHOT, AND IT CONTRIBUTES TO THE PRACTICALITIES OF ILLUSTRATING THE MODEL CLEARLY WITHIN THE BUSY SETTING.

The stark spot emulates bright, late-morning sunlight streaming through a window. All the details conspire to create the eroticism that the photographer wanted: the morning sunshine and suggestive "morning after" coffee, the model's sensual lingerie, the wittily-placed painting leaning against the wall so that the figure in it seems to avert his gaze, with a troubled expression, from the part of the model that is in startling proximity to his eyes.

The spot light is carefully positioned so as to give outline detail in the shadow of the model, but without too much density. It also casts shadows of the items hanging on the clothes line. Since these shadows fall on a darker-toned surface, the shadow is denser essential to make the model's right arm stand out.

► *The choice of lighting can establish a motivation and internal logic for the other facets of a shot (props, costume, and so on)*

► *It is important for the photographer to be aware of "tones and zones"*

Photographer's comment:

I wanted a natural but erotic scene.

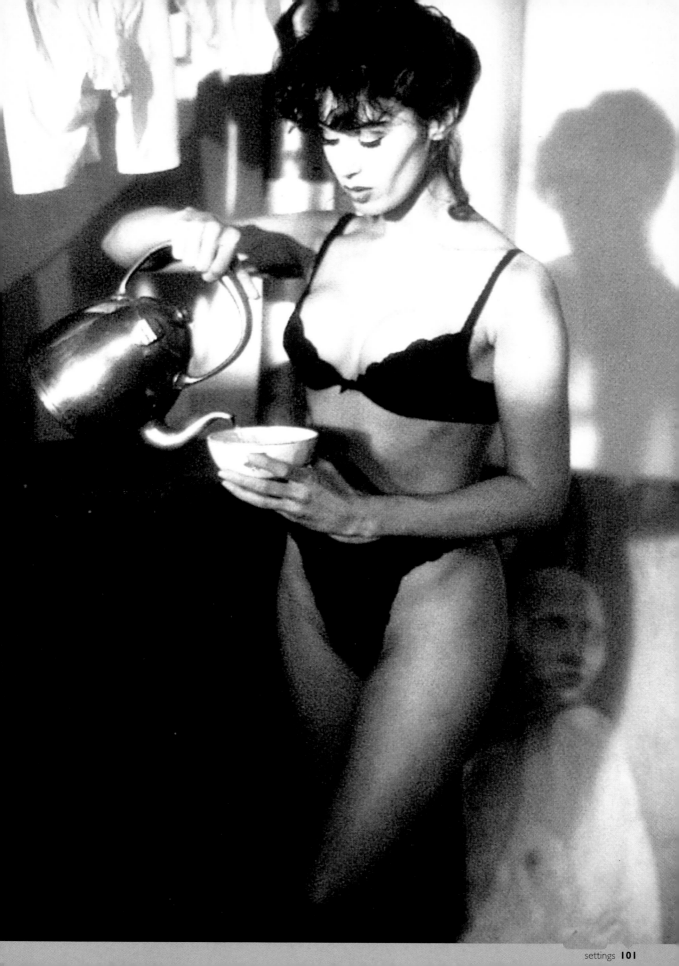

JACQUELINE IN THE BOX

▼

Photographer: **Michael Grecco**

Use: **Personal work**

Model: **Kelly Anderson**

Camera: **6x6cm**

Lens: **120mm**

Film: **Kodak EPY 64 (tungsten-balanced)**

Exposure: **1/15 second at f/8**

Lighting: **Electronic flash**

Props and background: **Los Alamos, New Mexico nuclear lab equipment**

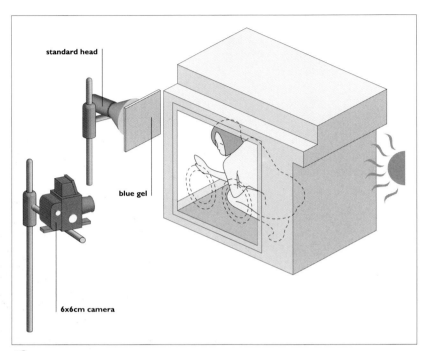

standard head

blue gel

6x6cm camera

"**S**KIN TONES REQUIRE A SURPRISING AMOUNT OF ADDITIONAL BLUE IN ORDER TO RECORD AS NEUTRAL", SAYS MICHAEL GRECCO. "I AM FOREVER ADDING BLUE FILTRATION."

For this particular shot, Michael used a 1/2 booster blue filter, resulting in the pale blue-tinged skin that he wanted. Although this was an outdoor daylit shoot, it was an overcast day and the model crouching inside the dark box needed additional flash lighting, provided by a Comet 1200 PMT. Since tungsten-balanced film was being used, the box (lit only by the ambient daylight) records as a rich, deep blue, while the skin retains its almost neutral tones and glows in the gloom from within the unnerving location set, giving this extraordinary and haunting look.

Photographer's comment:

The sudden rain added an ethereal look to this picture, taken at the Los Alamos nuclear lab's junk yard.

► *Full blue filtration results in the loss of two stops of light*

► *When this is used over a flash head the inverse-square law also applies*

Plan View

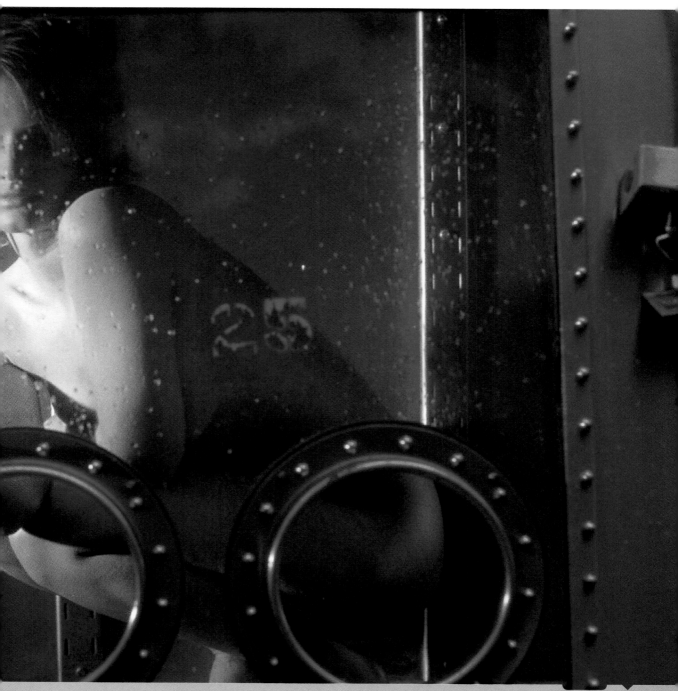

Photographer: **Michel Cloutier**

Camera: **35mm Contax RTSII**

Lens: **100mm f/2**

Film: **Kodak Tmax 400**

Exposure: **1/15 second at f/8**

Lighting: **Electronic flash: 2 heads**

Props and background: **Smoke machine**

Plan View

▶ *Lighting smoke and vapour clouds from the front gives a more "blanket" effect; lighting from behind reveals more detail in the texture and formation of the cloud*

▶ *There are different kinds of "smoke" machines, for example, dry ice (carbon dioxide) and cracked mineral oil, which give excellent visual results. However it is important to check what kind of vapour will be produced, since some vapours can form a coating on the camera lens that is difficult to clean off. The ensuing cleaning process may even scratch and cause permanent damage. An optical flat or a skylight filter (one that is cheap enough to be disposable) should side-step the problem if you are in any doubt*

▶ *Light in front of smoke is dispersed by the cloud. Light from behind smoke illuminates the smoke itself*

STEAM ROOM

▼

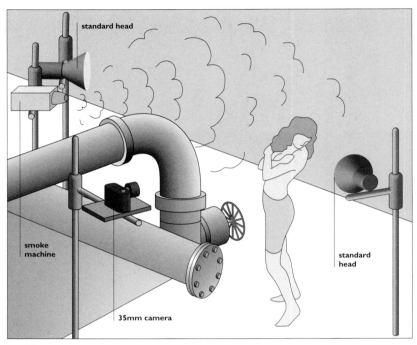

THE SETTING GIVES A MOTIVATION OF TEXTURE FOR THIS SHOT. THE ASSORTMENT OF MATERIALS - WOOD, METAL, STEAM, GREASE - ARE FASCINATING IN THEMSELVES, BUT MICHEL CLOUTIER ADDS TO THESE WITH THE OILY-SKINNED, FLUFFY-HAIRED MODEL, WEARING ONLY A SOFT BLACK TOWEL ABOUT HER HIPS.

The choice of black and white film focuses attention specifically on the range of textures and shades and the way the light falls on the various surfaces, produced by just two versatile sources. A strip light illuminates the machinery to the right of the camera from above – notice the shadows below the rivets on the plate on the lower-right edge. But it also gives long shining areas on the model's limbs, a finely curved, shaping highlight on the wheel directly in front of the model and a broader, softer highlight on the rounded edge of the tank to the left.

The steam (actually dry ice) adds atmosphere to the whole image and is lit by a 7-inch reflector to the right of the smoke machine. Lit from the front, the smoke itself disperses the light and acts almost as a reflector, allowing highlight details of the pipes behind the smoke to come through, and providing separation between the model and the background, especially her hair.

Photographer: **Frank Wartenberg**

Client: *Select* **magazine**

Use: **Editorial**

Model: **Alan and Ludmilla**

Assistant: **Jurgen**

Art director: **Frank Wartenberg**

Stylists: **Susan, Sabine**

Camera: **Mamiya RZ67**

Lens: **180mm**

Film: **Kodak EPR**

Exposure: **Not recorded**

Lighting: **Electronic flash: 5 heads and 2 soft boxes**

Props and background: **Bed, chair, table, painted backdrop**

Plan View

► *Lighting is strongly suggestive of mood. Tensions between contrasting areas of lighting can be suggestive of tensions in the subject matter (for example the coldness of the bedstead juxtaposed with the warmth of the rest of the shot)*

► *Separation can be achieved by using a long lens to reduce the depth of field as an alternative to the more common method of using a backlight, if back lighting is not appropriate to the mood*

B E D S T E A D

▼

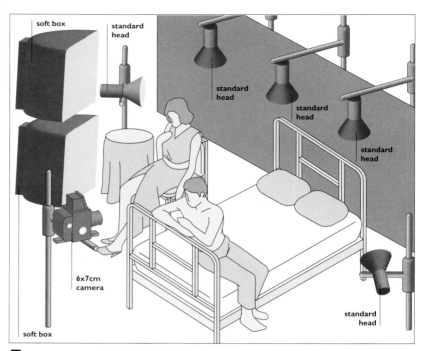

THE VOYEURISTIC QUALITY OF THIS SHOT DERIVES FROM THE TANGIBLE TENSION CONVEYED BY THE TWO CHARACTERS FEATURED. THIS SEEMS TO BE AN INTENSELY PRIVATE MOMENT, PERHAPS OF FRICTION, UNCERTAINTY OR ATTRACTION — SEVERAL INTERPRETATIONS ARE POSSIBLE.

The posing and expression of the models obviously play a major part in creating this effect, but so too do the colour, setting and texture of the subject, sympathetically lit. The wall, the clothing and the skin are all of much the same colour tones, lit deliberately to merge and confuse these various areas of the subjects to imply the confused connections between them. Five flashes give even light on the woman and the background and the use of an orange filter over the camera lens lends relative uniformity to the colour range.

Only the bedstead, lit by two soft boxes, has a cold glow of its own, the intensity of light outweighing the effect of the light orange filter on the camera. The male model, lit by the same two soft boxes, is posed to give areas of shadow on the body and face to emphasize the moody feel of the shot.

Photographer's comment:

The whole set is built in the studio.

Photographer: **Frank Wartenberg**

Client: **Fit for Fun**

Use: **Editorial / cosmetic**

Assistant: **Bert**

Stylist: **Laurent Bovas**

Camera: **Mamiya**

Lens: **185mm**

Film: **Fuji Velvia**

Exposure: **Not recorded**

Lighting: **Electronic flash: 6 heads**

Props and background: **Built set, light orange background**

Plan View

► *It is important to light the whole of the set from the beginning, even if you plan to frame very little of the background. This allows for greater latitude and experimentation with framing and model-directing once the shoot has begun, without interruption for complete re-positioning*

► *Even the smallest amount of rim-light separation can make all the difference in providing good clear definition of a model's features, avoiding the danger of one feature appearing to merge unflatteringly into another – the infamous "chinless wonder" phenomenon*

MASSAGE

▼

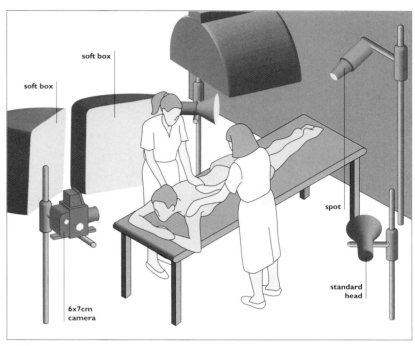

THE USE OF THE 81A ORANGE FILTER CONTRIBUTES A RICH, LUXURIOUS WARMTH TO THIS SHOT. ALTHOUGH THE OVERALL LIGHTING IS QUITE SOFT, SUPPLIED BY THE TWO FRONT SOFT BOXES, THERE ARE ALSO AREAS OF HARD HIGHLIGHTS TO GIVE A DEFINITE SHINE ON PARTS OF THE MODEL'S BODY AND ON HER HAIR, AS WELL AS ON THE ARMS OF THE MASSEURS.

These areas of contrasting hard light and the shining areas that they produce are significant in three respects. First, the shine on the body is important to establish the idea of a massage oil being applied. Secondly, the shine on the back of the hair and on the arms of the masseurs gives the idea of warm sunlight streaming in through a rear window. Both these aspects of shining highlights are achieved by the close-in rear soft

box. Its proximity has the effect of providing apparently harder directional light, giving rise to the high-key areas on the skin.

Thirdly, the hard light from the focusing spot specifically picks out the back of the hair and gives the outline of light below the ear. It is this detail that provides the essential separation between the face and the shoulder.

Photographer: **Rob Maclese**

Client: **Paramol**

Model: **Louise Glover at Boss**

Art director: **Ian Pinches**

Agency: **The Quay**

Camera: **Mamiya RB67**

Lens: **127mm**

Film: **Kodak EPP**

Exposure: **f/8.5**

Lighting: **Bowens and Broncolor**

Plan View

G Y M

▼

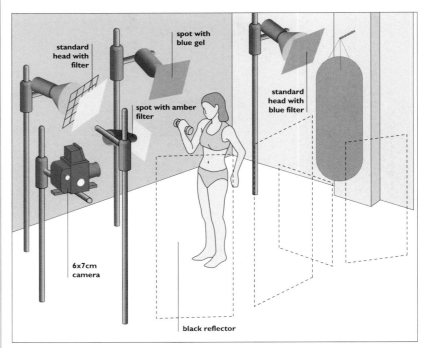

"**T**HIS WAS SHOT AS PART OF A SERIES OF IMAGES FOR PARAMOL.
THE ADS APPEARED IN THE LIKES OF *ELLE*, *COSMOPOLITAN*, ETC. AS BLACK AND WHITES.
BLACK AND WHITE WAS THE ORIGINAL BRIEF, BUT COLOUR WAS SHOT FOR THE RIGHT
GRAIN STRUCTURE," EXPLAINS ROD MACLESE.

The correct props are essential for establishing the scene for this studio shot. A punch-bag is subtly lit so as to appear almost in silhouette in the background to reinforce the gymnasium context. The lighting for this area consists of a Broncolor snooted dish on a boom arm with a blue filter, just out of frame to the left; and a Bowens square snoot also with a blue gel, which also gives an area of highlight on the punch bag. Finally, the black reflector on the right of the bag flags off any light that might be reflected back from the white walls of the studio.

The model subject is keyed from the left side by a Bowens square light with slats and an amber filter. Opposite are two black panels, which make the square light more directional. A Bowens spotlight just to the right of camera picks out the back of the model's pony-tail.

► *The coloured effect of lighting an area through a gel can easily be spoiled by stray uncoloured (or wrongly coloured) spill light, which is not necessarily visible to the naked eye so meticulous flagging is essential*

► *Even a minimally-lit background prop can contextualize a shot effectively*

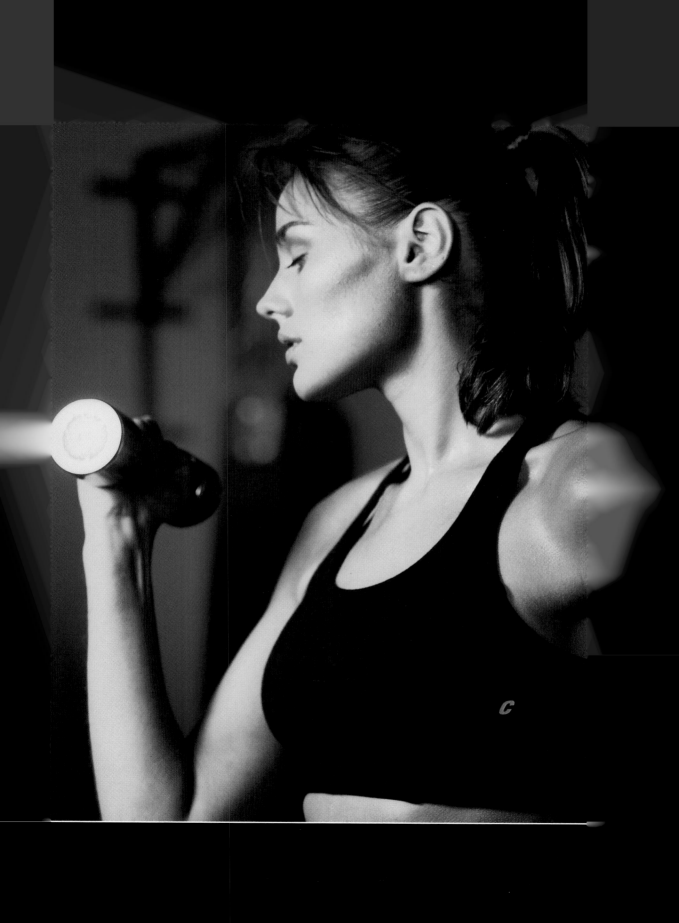

Photographer: **Kazuo Sakai**

Use: **Test**

Make-up: **Matsumoto**

Camera: **Nikon F4**

Lens: **35mm**

Film: **Fuji RHP400 rated at 1600**

Exposure: **1/60 second at f/2**

Lighting: **Electronic flash: 1 head**

Props and background: **Concrete wall, 2.5 m high ceiling**

Plan View

▼

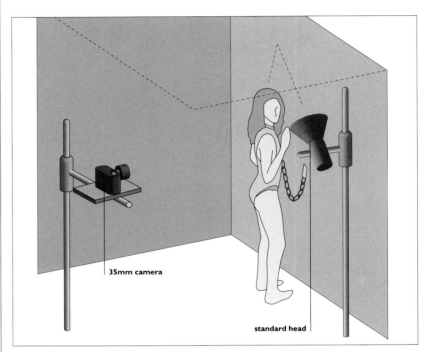

35mm camera

standard head

THIS IS ANOTHER EXAMPLE (LIKE FRANK WARTENBERG'S "LINGERIE" SHOT ON PAGE 101), WHERE THE STYLE OF LIGHTING CONTRIBUTES AS MUCH TO THE SUGGESTED STORY AND CONTEXT OF THE IMAGE AS IT DOES TO THE PRACTICAL ILLUMINATION AND VISUAL IMPACT OF THE SHOT.

By bouncing the sole light off the ceiling, Kazuo Sakai creates the illusion of top lighting, as if from a high up window or skylight, consistent with the imprisonment cell setting that the picture suggests. The props, clothing, make-up and styling all also contribute to establishing the context.

To create the initial grainy effect, 400 ISO film was used and pushed 2 stops, giving an effective ISO of 1600. A positive image of textures and colours was created, using pastel crayons and this was sandwiched together with the first for the final result.

► It is often best to shoot an image "clean" rather than shooting with a texture screen, since this gives more versatility at the printing and post-production stage

► Even, bounced light gives a hard shadow when used at a relatively close proximity

Photographer's comment:

Rust colour and pastel crayons added to a second positive, then printed together for overlay effect.

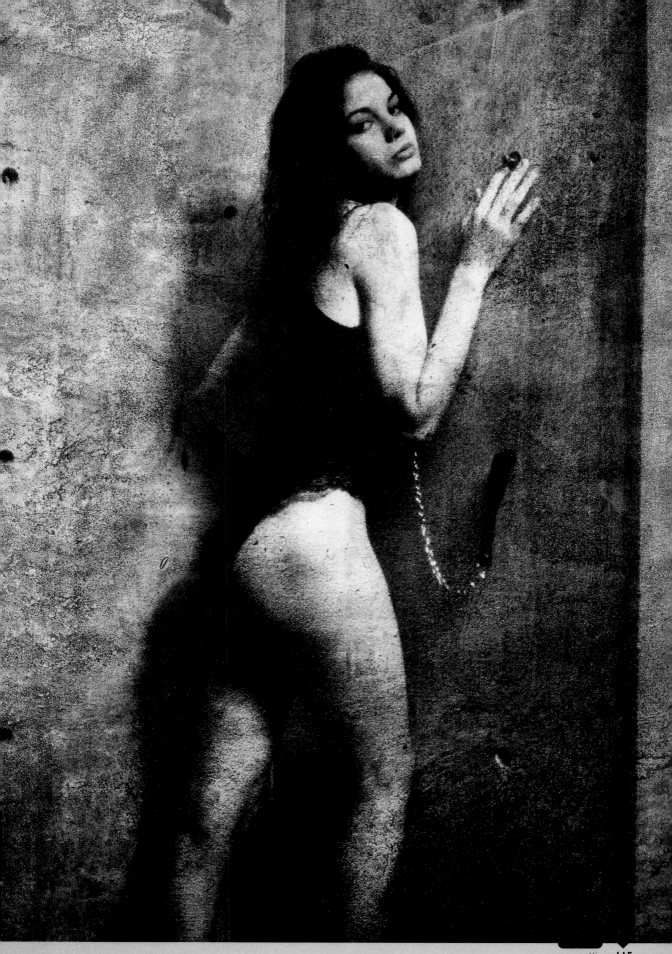

Photographer: **Günther Uttendorfer**

Client: *Kankan* **magazine, Slovakia**

Use: **Editorial**

Model: **Lyvia (Slovak Model Management)**

Assistant: **Martin Fridner**

Make-up: **Martina Valentova**

Art director: **Ivan Sloboda**

Camera: **35mm**

Lens: **105mm f/2.5**

Film: **Polapan**

Exposure: **f/2.5**

Lighting: **Electronic flash: 1 head**

Props and set: **Factory location, Bratislava**

Plan View

► *Settings can suggest not just a mood and provide motivation for a shot, but can also imply endless possible narratives*

► *Be aware of light hitting the lens directly and causing flare*

L Y V I A

▼

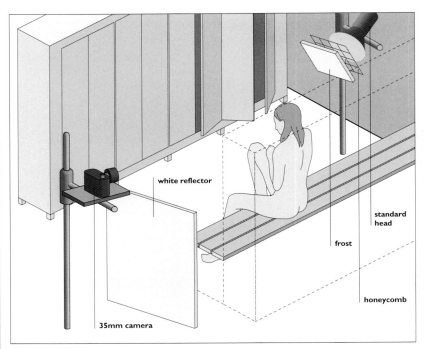

white reflector

standard head

frost

honeycomb

35mm camera

THE BACKLIGHT OF WHICH GÜNTHER UTTENDORFER IS SO FOND IS USED TO GOOD EFFECT HERE, GIVING A BRILLIANT POOL OF LIGHT THAT OBSCURES AND OUTSHINES THE FOREGROUND, BUT NOT DAZZLING THE CAMERA COMPLETELY.

A white reflector gives a little definition to the near side of the model, just enough to make out her expression and pose and thus establish the mood. There is slight movement on the model's part, giving softness and again adding to the obscuring of the near-ground to keep the air of mystery. The brilliant flash (a standard head with honeycomb and frost) at the far end of the set catches the wispy extremes of the hair and the curves of the face and shines along the floor surface to put the leg into silhouette. Although much of the composition of the set leads the eye along to the central keylight at the far end (the slats of the bench, the path of the ground, the locker vents), the off-centre, shadowy model remains the focus of attention for the very reason that she is not clearly visible, is not the predominantly brightly-lit element, and therefore the photo has an intriguing mysterious quality that captures the eye and imagination.

Photographer's comment:

I love back-light flashing directly into the lens with little light from the foreground. That makes the picture look somewhat mysterious. You've got to be careful with posing the backlight.

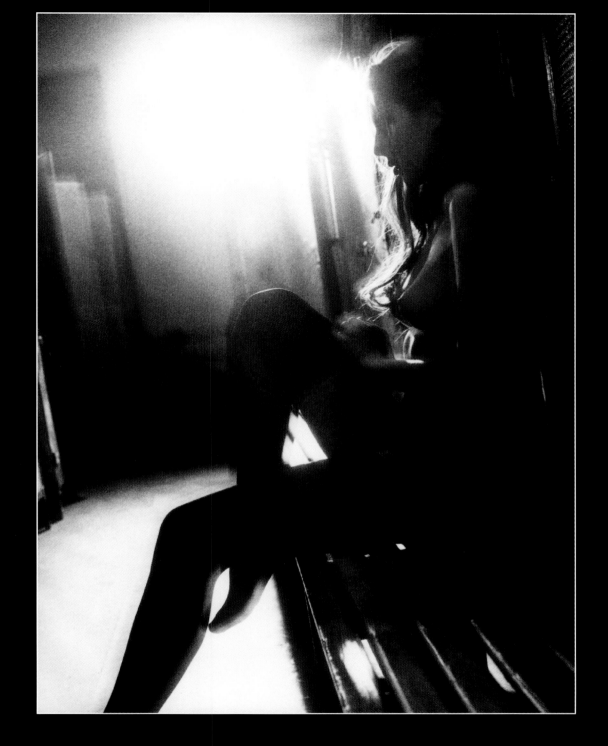

6 raucous and raunchy

▶ The raucous and the raunchy have always had a central place in glamour photography. As time goes by, what is perceived as outrageous is always changing, so the potential subject matter and variety of approaches possible are always growing. Perhaps the freedom to look at more in these modern, "anything goes" days, has led to an opportunity to look harder, and in different ways, at things that would not at one time have been looked at at all. There will always be local cultural variations around the world in what is and what is not acceptable for view, but so too will those boundaries always be changing in any given place. The work in this chapter represents a view of the parameters for these photographers, in their own particular environments, at a certain point in time.

One interesting element, as mentioned in the introduction to this book, is the confrontational air that many of these shots have. The models are not simply objects for the viewer's consumption, but are often portrayed as pro-active, aggressive, dominating and certainly not passive. They are posed assertively, often looking straight out at the camera, challenging the viewer with a disarming directness. There is little of the traditional coyness in these images. The sensuality is blatant and the models are bold.

Photographer: **Frank Wartenberg**

Use: **Self-promotion**

Camera: **Mamiya RZ67**

Lens: **110mm**

Film: **Fuji Velvia rated at 40 ASA**

Exposure: **Not recorded**

Lighting: **Electronic ring flash**

Props and background: **Wild cat backdrop**

Plan View

THE CAT LADY

▼

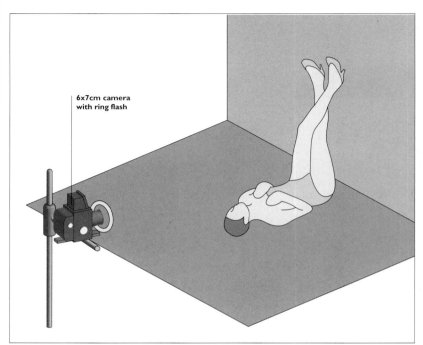

6x7cm camera with ring flash

THIS IS AN EXAMPLE OF THE IDEA THAT "ENOUGH IS PLENTY". IF ONLY A SINGLE RING FLASH IS NEEDED, THEN JUST USE A SINGLE RING-FLASH. FRANK WARTENBERG IS NOT AFRAID TO USE A WHOLE HOST OF LIGHTS IF THE OCCASION DEMANDS IT, BUT IN THIS INSTANCE A SINGLE SOURCE WAS ALL THAT WAS REQUIRED FOR THE LOOK THAT HE WANTED.

The positioning of the black material on the floor was an important decision, because it introduces a horizon line where the floor meets the wall, and helps the viewer to make sense of the model's pose. The "geography" of the shot might otherwise have been difficult to understand. The ring flash gives a wall of light on the leopardskin background. The cloth has texture, movement and tone enough of its own to give the variation and interest required. The white, fetishy stiletto shoes are very evenly lit, giving a highly graphic form. Here, it is the contrast in colour between the high-key shoes and the low-key area of the background that provides separation.

► *A lot can be achieved with even the minimum of lighting*

► *High-key detail can add to the stark impact of a deliberately startling shot*

Photographer's comment:

I wanted a powerful and erotic photo!

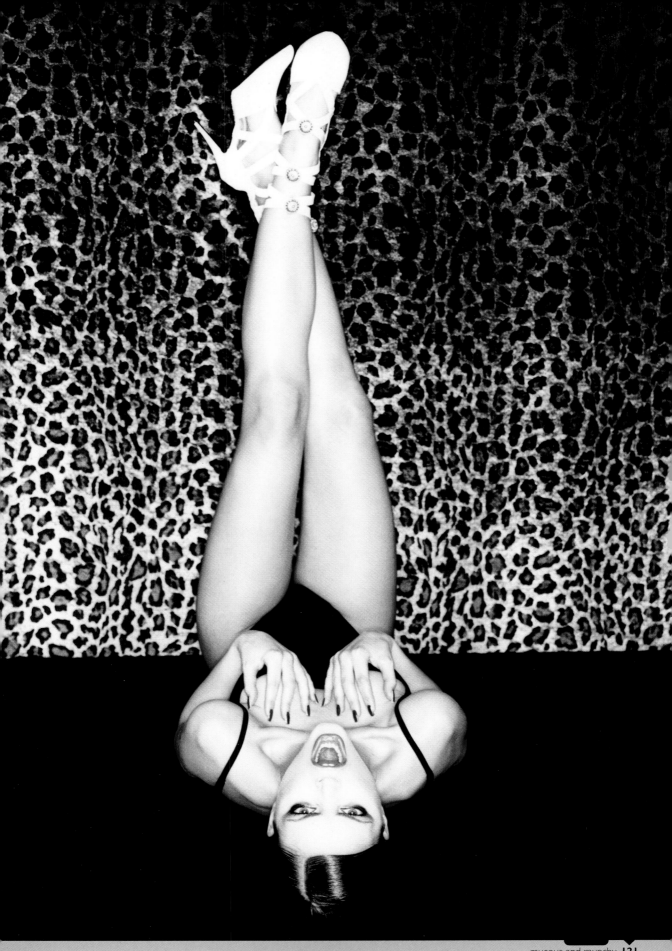

Photographer: **Tim Orden**

Use: **Personal work**

Model: **Konnie**

Assistant: **Donna Orden**

Camera: **35mm**

Lens: **80-200mm**

Film: **Fuji Realla**

Exposure: **1/250 second at f/8**

Lighting: **Electronic flash: 1 head**

Props and background: **Motorcycle repair shot**

Plan View

RE-CYCLE SUNRISE

▼

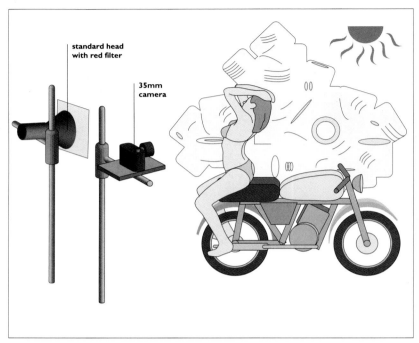

As ever, Tim Orden provides the best insights into his own photographs.

"Believe it or not, this model was in the US Navy at the time of this shoot. Airman Konnie, as she became known to me, was a young woman with all the problems you might expect from a very attractive, eligible gal: Konnie couldn't seem to keep her relationships very stable!

"Nevertheless she was a good model. Always willing to get the job done without a lot of grief. We created this image in front of a motorcycle repair shop. Notice that she looks wet: this is as a result of her splashing herself with the road puddle water that had been sitting as a result of a recent shower. I have to hand it to this 'airman', she was tough."

Daylight was the main source, with a filtered red flash as a 'kicker'. The daylight was under-exposed by 1 stop and the portable flash was set to maximum output (f/11 as metered at model). The negative was digitized (drum scanned) and played with in Photoshop 4.0.

► *The introduction of a small amount of coloured light can really add to the mood of an image*

► *When investing in computer hardware and software, be sure the equipment offers what you want to be able to do*

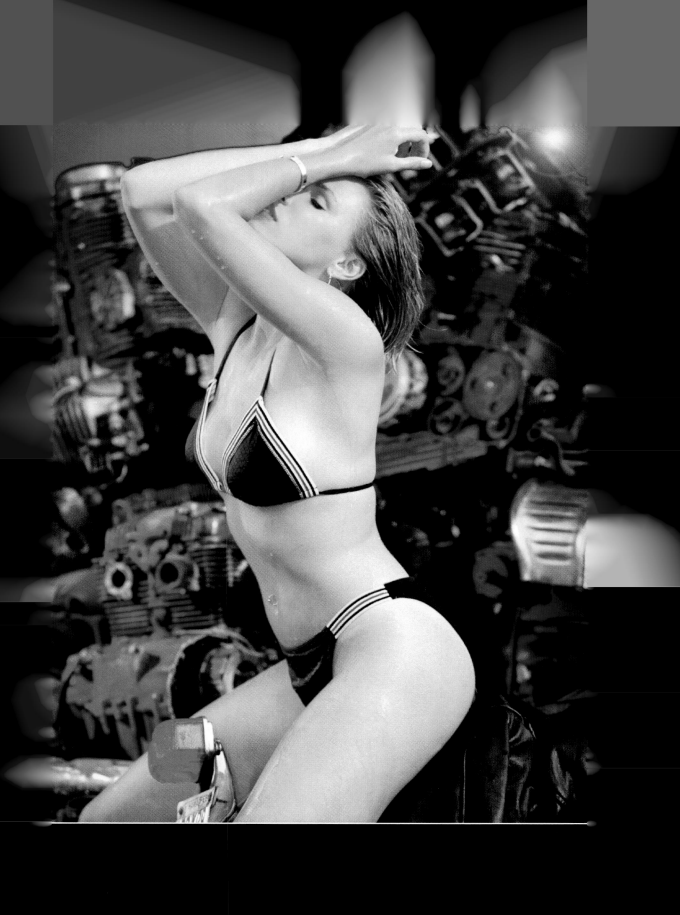

E R O T I C A R T

▼

Photographer: **Frank Wartenberg**

Client: **Art Buyer's Calendar**

Use: **Advertising**

Model: **Brigitte**

Assistant: **Marc**

Art director: **Frank Wartenberg**

Stylist: **Ulrike, Uta**

Camera: **Nikon F4**

Lens: **85mm with orange filter**

Film: **Polaroid Polagraph**

Lighting: **Electronic flash: 1 soft box**

Props and background: **Grey background, old leather furniture**

Areas of dark are just as important as light in this shot. The absolute blackness of the shiny leather seat and the regular pattern of the black tights give two major areas of visual impact. The large, long soft box running almost the entire length of the couch gives a dazzling highlight along its edges but the fabric of the clothing remains matt in texture and unlifted by any catch-lights, by way of contrast. The reflectors bounce in just enough light to provide some fill.

The grey of the background represents the brightest area of the shot and the model's body displays every tone in between, encompassing a highlight on the midriff that is equivalent in brightness to the background, down to a shadowy hand that is almost as dark as the leather. The position of the soft box, slightly closer to the model on the camera left side, gives some degree of directionality, so the front of the model is bathed in light while the head and arms are flung into more shadowy territory. The modelling on the rounded breast (nearest to the camera) perfectly displays the gradation of light from one side to the other.

Photographer's comment:

Erotic art – the body like a statue.

► A high-contrast stock, even when
modified with an orange contrast filter,
can still be lit to give a medium-contrast
look

► Observe the splendid example of
graduated light on a perfectly smooth,
rounded subject, item, object, receptacle

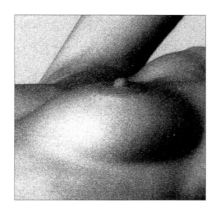

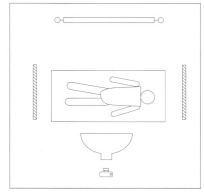

Plan View

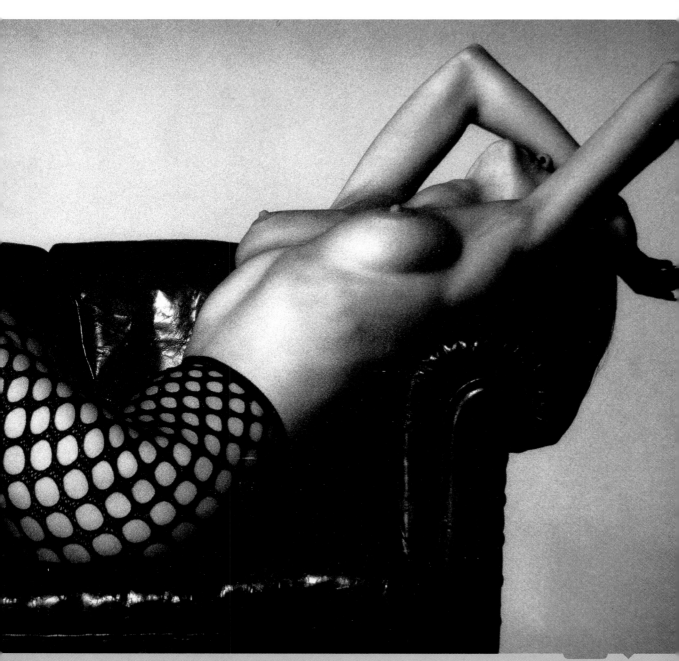

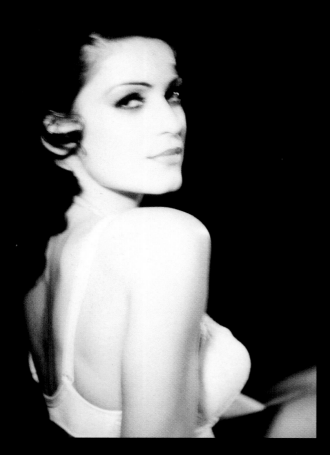
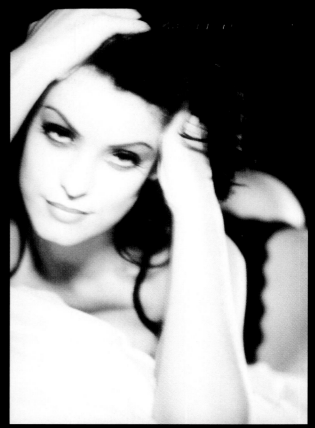
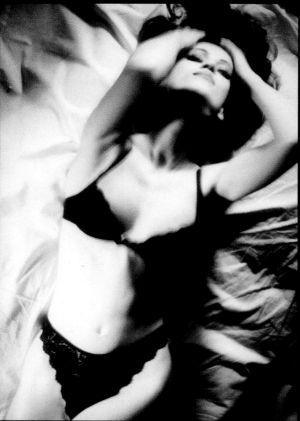
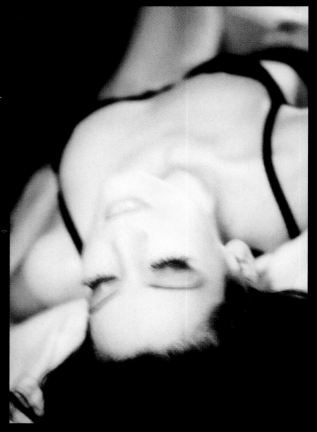

Photographer: **Günther Uttendorfer**

Client: **Kankan magazine, Slovakia**

Use: **Editorial**

Model: **Natasha, Slovak Model Management**

Assistant: **Martin Fridner**

Art director: **Ivan Sloboda**

Make-up: **Martina Valentova**

Camera: **35mm**

Lens: **105mm**

Film: **Polapan**

Exposure: **1/8 second at f/2.5**

Lighting: **Tungsten**

Props and background: **Bed with white sheets, black paper**

Plan View

► *A red filter would heighten the contrast even further, but it can become difficult when working quickly to be sure that the focus is accurately set*

► *When using instant Polaroid film stocks it is important to make sure that the processor is immaculately clean, since the film can scratch very easily*

N A T A S H A S E R I E S

▼

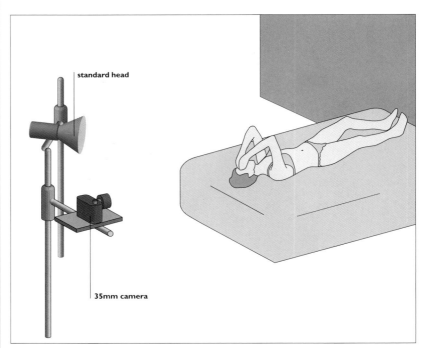

THIS AGAIN IS ANOTHER EXAMPLE OF A VERY SIMPLE SET-UP, WITH JUST ONE 500-WATT TUNGSTEN HEAD WITH A STANDARD REFLECTOR AND FROST, THE ONLY SOURCE USED THROUGHOUT THE WHOLE SEQUENCE.

The head is placed to camera left and its position stays constant for the whole shoot. However it is the model and the photographer who change their relative positions, introducing variations in composition and lighting, and revealing to differing degrees the textures in the fabrics of the model's clothing and the sheets. The model's lingerie also changes between shots, giving different plays of light and dark in the sequence of shots.

What comes through all the pictures is the model's personality, engaging effectively with the camera, a quality heightened by considering the shots as a sequence, as they are presented here.

A shutter speed of 1/8 second is used to introduce the feeling of movement and give the images a slightly soft edge in contrast with the relatively harsh direct light. Use of an orange filter increases the contrast.

Photographer's comment:

It really is a lot of fun if a girl reveals her character in front of the camera and interacts with it. This creates for me the erotic feeling of a series.

Photographer: **Marc Joye**

Use: **Portfolio**

Model: **Genevieve**

Camera: **6x6cm**

Lens: **80mm**

Film: **Kodak Tmax 100**

Exposure: **1/60 second at f/16**

Lighting: **Electronic flash: 2 heads**

Props and background: **Plinth, dark red fabric**

Plan View

L O W K E Y

▼

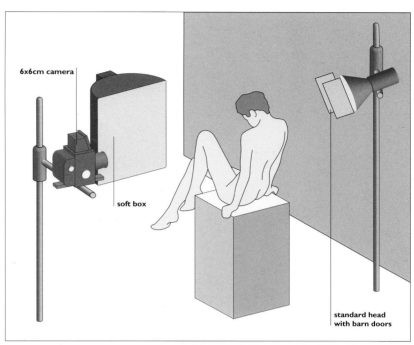

6x6cm camera

soft box

standard head
with barn doors

A FEW HIGH-KEY AREAS MAKE FOR AN OVERALL LOW-KEY IMAGE. THIS MAY SOUND
LIKE A CONTRADICTION IN TERMS, BUT THE EXPLANATION IS TO DO WITH THE PROPORTION
OF THE OVERALL IMAGE THAT IS HIGH-KEY (VERY LITTLE IN THIS CASE) IN RELATION
TO HOW MUCH OF IT IS LOW-KEY.

The fact that there is absolutely no direct light on the background – and the background occupies a large amount of the frame – determines the immediate "feel" of quiet greyness. The geometric form of the model is more important than close detail, and the strongly directional lighting is designed to emphasize the graphic element of her carefully balanced pose, with the visual balance of relatively small areas of high-key shine on the extreme right of the model (her back) and on her left (the front of the lower legs). The fulcrum is the V-shape formed by the thigh and abdomen, and the sense of pivotal balance is picked up by the fine rim of light on the left edge of the plinth, which is positioned so as to control exactly how much of each side is in view. Just a fraction of the left side is visible, giving the fine line of light, whilst the right side is turned away just enough to ensure that no edge light appears.

► *The term "key light" is generally used to mean the dominant or more powerful light source, and is usually the first consideration when planning the set-up: the style and placing of the keylight often dictates the nature of the supporting lighting*

► *Careful use of geometric form can give a powerful, balanced visual impact*

Photographer's comment:

Here the model was moving and changing poses that were very powerful.

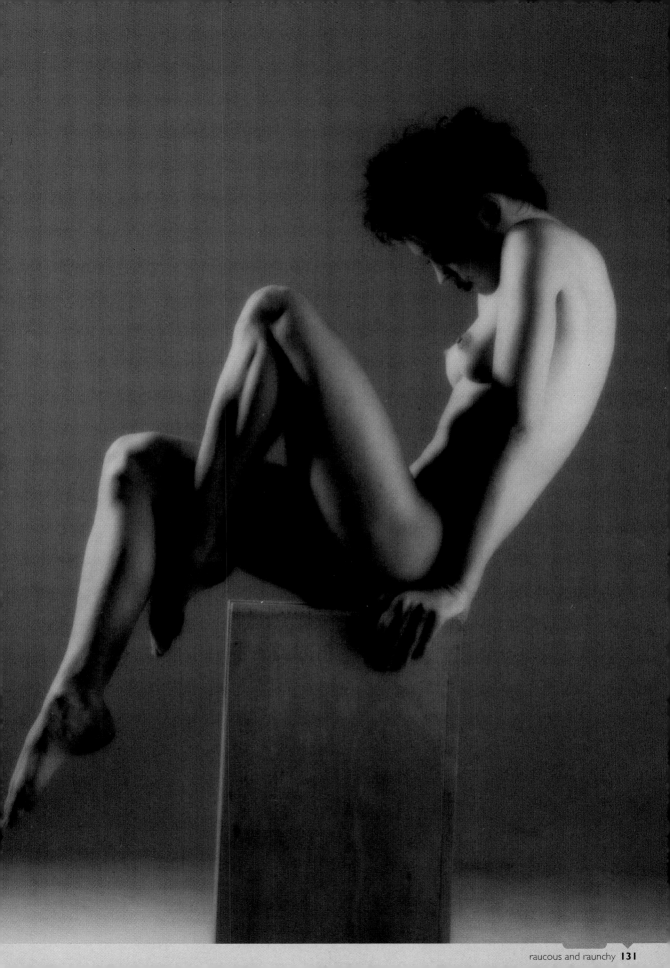

Photographer: **Frank Wartenberg**

Client: *Stern* **Magazine**

Use: **Cover/Fashion**

Model: **Gabriella**

Assistant: **Bert**

Stylist: **Gudrun, Uta**

Camera: **Mamiya**

Film: **Fuji RDP 100**

Exposure: **Not recorded**

Lighting: **Electronic flash**

Props and background: **Golden wall**

Plan View

► *Reflective props and accessories can add interesting glints of detail if lit appropriately*

► *Sometimes areas of both sharp and soft focus on the same main subject can enhance the image*

G A B R I E L L A

▼

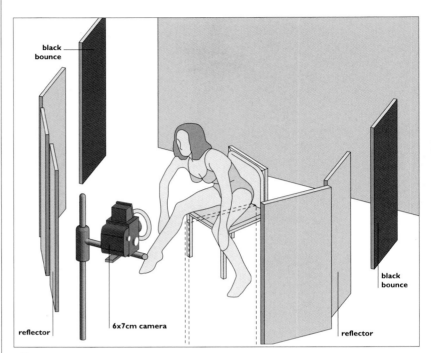

ALTHOUGH THE ONLY SOURCE OF LIGHT IS A SINGLE RING FLASH, THIS SHOT IS ILLUMINATED BY ALMOST ALL-ROUND LIGHTING, ENSURED BY THE USE OF A BANK OF REFLECTORS ARRANGED IN A SEMI-CIRCLE IN FRONT OF THE MODEL AND A REFLECTIVE GOLDEN WALL BEHIND HER.

The only break is that provided by two black panels, one to each side of the model, which have the effect of allowing some fall-off to occur on the side edges of the limbs and body. Even the chair is made from reflective metal, giving glowing metallic blue areas behind the model. The pose of the model means that her face is considerably closer to the flash than the rest of her body, and the resulting difference in tone is immediately apparent, as the face is comparatively burnt out though sharp, while the body has a darker golden tone and is in softer focus. The highlights on the bangles, shoe, chair seat and back and on the model's lips add balanced points of interest across the image.

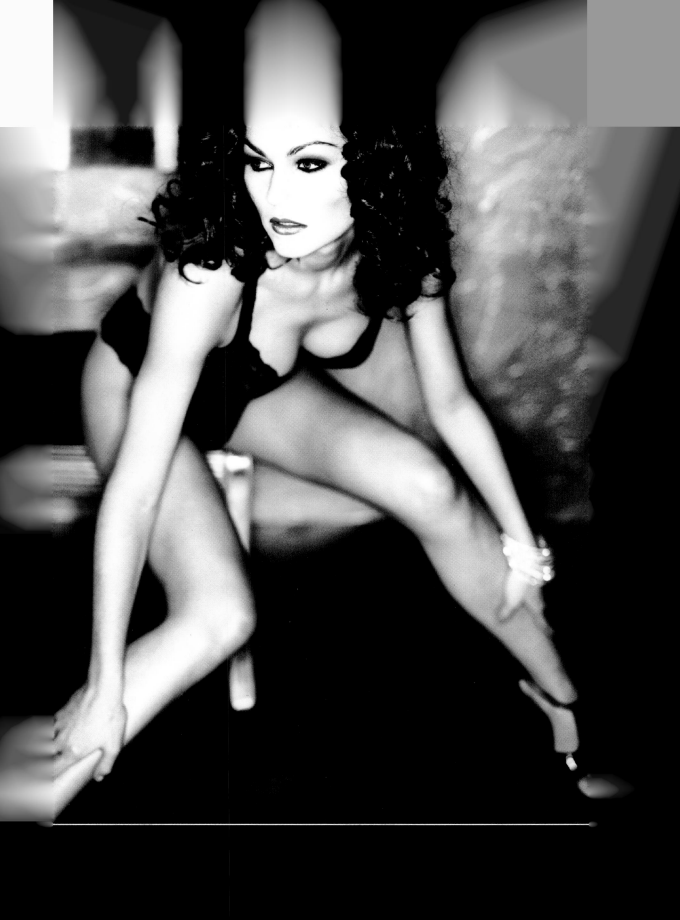

raucous and ra

Photographer: **Marc Joye**

Use: **Portfolio**

Model: **Genevieve**

Camera: **6x6cm**

Lens: **80mm**

Film: **Tmax 100 and Fuji RDPII**

Exposure: **1/60 second at f/16**

Lighting: **Electronic flash: 4 heads**

Props and background: **Feathers**

Plan View

F E A T H E R S

▼

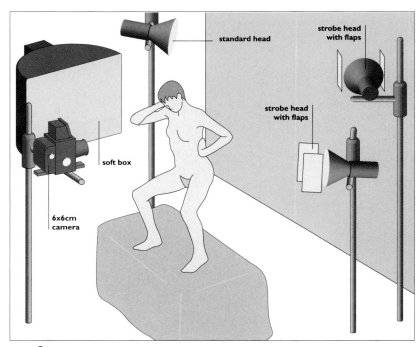

SEEING IS BELIEVING, BUT IT IS HARD TO BELIEVE THE SIZE OF THE INCREDIBLY LARGE FEATHERS THAT COMPRISE THIS EXTRAORDINARY HEAD-DRESS. OF COURSE, THEY ARE UNBELIEVABLE BECAUSE THEY ARE NOT ACTUALLY "TRUE". THEY ARE IN FACT SMALL FEATHERS LAID ON TO A PRINT OF THE SHOT OF THE MODEL, AND THE WHOLE ASSEMBLY RE-PHOTOGRAPHED. THE *TROMPE L'OEIL* IS SURPRISINGLY CONVINCING. NOTICE THE GENTLE SHADOW BEHIND THE HEAD FEATHERS, THE WORK OF SUBTLE MANUAL RE-TOUCHING TO COMPLETE THE THREE-DIMENSIONAL ILLUSION.

The background is illuminated much more brightly than the model. Two strobe heads aimed at the backdrop give a bright, even background. The position of the soft box to the side of the model does not give much strong, direct light on the front of the body, and the strobe behind her on the opposite side gives back lighting that adds to the tendency towards silhouette. The drawn-in pattern on the torso stands out by virtue of the colour, in contrast with the soft black and white base image and pastel feather shades, a striking finishing touch indeed.

► *Simple, physical techniques used in a sophisticated way can result in a shot that others might execute in a time-consuming, expensive electronic way*

Photographer's comment:

After shooting the photos, I designed some black calligraphy on her body. After printing I re-worked the calligraphy in red and added some pigeon feathers as a hat and to cover the pubic hair.

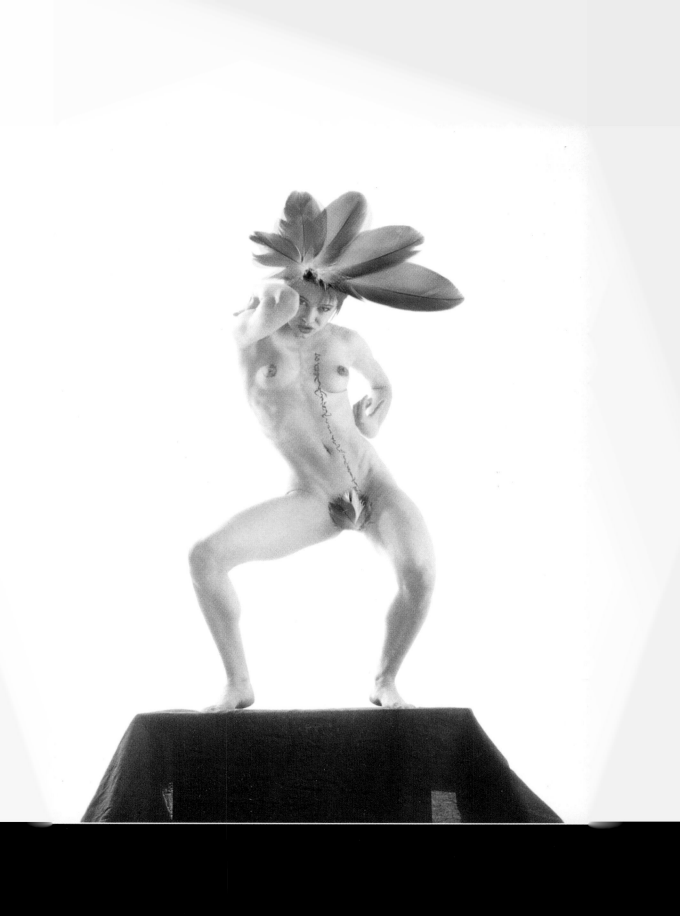

Photographer: **Günther Uttendorfer**

Use: **Portfolio**

Model: **Dagmar**

Assistant: **Jurgen Weber**

Make-up: **Nicole Friedl**

Camera: **35mm**

Lens: **105mm**

Film: **Polaroid Polapan**

Exposure: **f/8**

Lighting: **Electronic flash: 4 heads**

Props and background: **Metal chair, rope, cube**

Plan View

▶ *Lighting can be used selectively to conceal, as much as to reveal, a subject*

▶ *The structure of the metal strands that form the legs and back of the chair is virtually indistinguishable from the twisting strands of the rope and catches the light in a similarly interesting way*

B O N D A G E , D A G M A R

▼

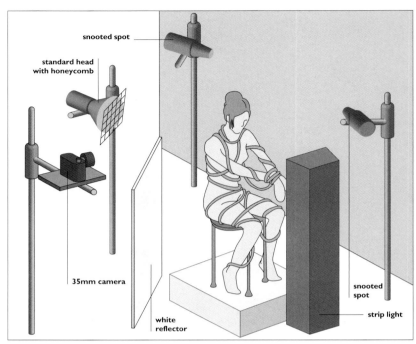

FOR ALL THAT IT IS AN OVERT LOOK AT A TABOO SUBJECT MATTER, SUBTLETY IS THE ESSENCE OF THIS SHOT AND THE FINELY-TUNED, RESTRAINED LIGHTING IS ALL-IMPORTANT.

Whereas many shots are lit so that the areas of the model facing the camera take the maximum lighting for clear detail, with fall-off occurring on the edges (see "Gabriella and dog" on page 75, for example), the opposite is true here. The darkest areas of the body face the camera and light is used on the periphery instead. The effect is to "cloak" some of the model's nudity in shadow, and to stimulate the imagination by limiting what is immediately visible.

The model is placed against a grey background. However this is not evenly lit, but two focusing spots, producing a circular pool of light behind the model, suggest interrogation spotlights. A strip light to camera right illuminates the front of the model's body and a white reflector opposite this lifts the shadows on the side of the body towards the camera. The fine light of line along the edge of the model's back is provided by a 500-watt head with honeycomb.

Photographer's comment:

Shooting photographs of themes which are taboo for most people is very difficult. I put a lot of effort into my shots to make them look erotic and not pornographic. You also need a very professional and a very relaxed model.

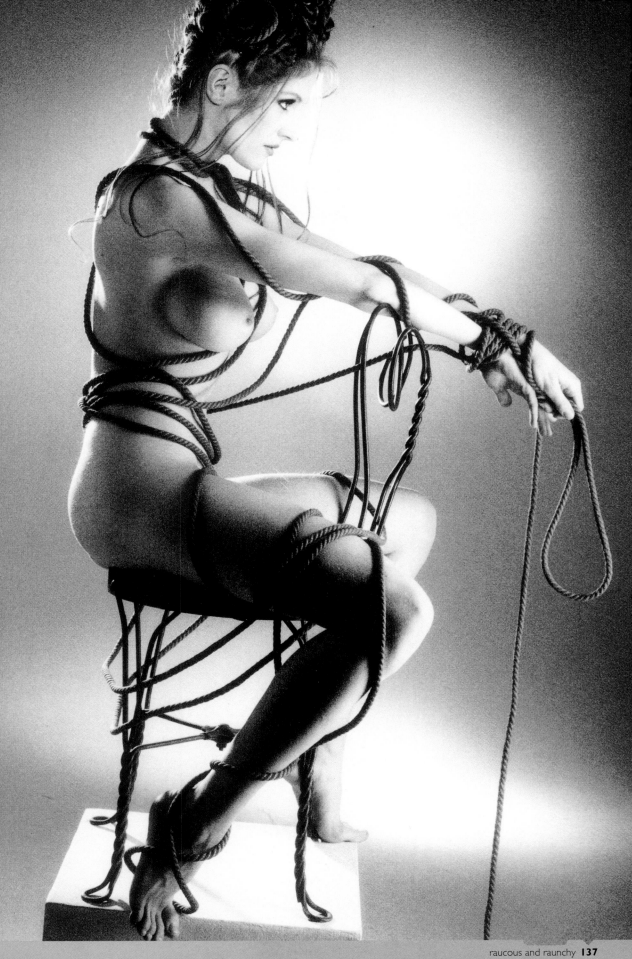

7

the
unexpected

The shots in this last chapter have in common the fact that they are all in some way one-off pictures. Some of them could have been allocated to other chapters in the book, but all of them have an individuality that makes it difficult to force them in to fit under not-quite-appropriate headings. In some there is a sense of humour or element of absurdity which sets them apart. In others it is the sheer inventiveness of the idea or use of an unusual technique that separates them out. And then there are those shots that are quite simply unlike anything else and defy categorization.

An element of the unexpected is a powerful quality to bring to a photograph. Not surprisingly, most of the work in this chapter is personal work, where the photographer can pursue an idea in unexpected directions, without having to be accountable or fit the brief of anyone else. The creative juices are flowing and the results are extraordinary because there are no holds barred. That is not to say that without restrictions an idea pursued imaginatively has to be in some way outrageous or excessively flamboyant; far from it, in fact. The art is to know when to keep going with an idea and when to stop. Self-editing is a skill in itself.

Photographer: **Ron McMillan**

Client: **Harkwell Group**

Use: **Calendar**

Model: **Verna**

Assistant: **Rob Bright**

Art director: **Ron McMillan**

Camera: **4x5 inch**

Lens: **210mm**

Film: **Ektachrome 64**

Exposure: **f/32**

Lighting: **Electronic flash**

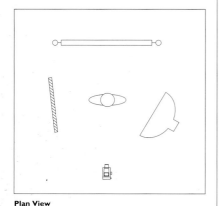

Plan View

GIRL WITH BLINDFOLD

▼

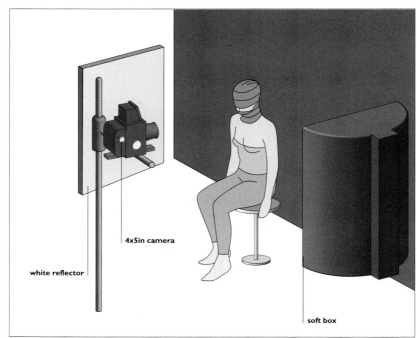

4x5in camera

white reflector

soft box

SIMPLE, EVENLY DISTRIBUTED ILLUMINATION SLIGHTLY SIDE-ON WAS USED TO GIVE
MOULDING AND SHAPE, SINCE A CLEAR VIEW OF THE PRODUCT IN CLOSE-UP IS WHAT
THE CLIENT REQUIRED, AS RON MACMILLAN EXPLAINS.

"This shot was one of a series for a group of printing companies, each shot depicting one of the group's printed products. This one is for printed fabric labels, which are produced on reels.

"The model was wrapped in these reels of fabric tape for several hours whilst we tried alternative versions of strawberries / cherries / glycerine, gloved hands etc. The model needed constantly to tidy up and renew her lipstick, but we couldn't allow her to remove the blindfold as all the reels were fixed at the back of her head. However she was able to balance a mirror on her lap and look down underneath the blindfold to achieve the running repairs.

"The secret of shots like this is to make an essentially boring product feel sexy, as per client request, but without being too crude or obvious in the presentation. 'Subtle' and 'suggestive' are the key words."

► *Even when the basic concept for a shot has been agreed with the client, it is worth trying out variations on the theme on the day – but be prepared with a range of supplies for experimentation*

► *An essentially dull product need not mean a dull product shot*

Photographer: **Juan Manuel García**

Client: **DFL Television**

Use: **Advertising**

Model: **Paola Trurbay**

Assistant: **Carlos Barren**

Stylist: **Alejandro Ortíz**

Camera: **6x6cm**

Lens: **150mm**

Film: **Kodak Ektachrome EPP 100**

Exposure: **3 minutes**

Lighting: **Light brush**

Props and background: **Red and blue velvet for the background**

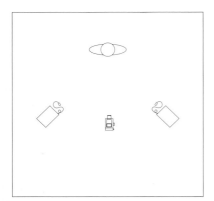

Plan View

P A O L A

▼

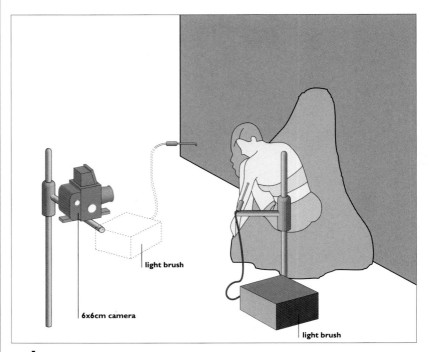

light brush

6x6cm camera

light brush

JUAN MANUEL GARCÍA USED A LIGHT BRUSH TO PAINT-IN THE REQUIRED AMOUNT OF ILLUMINATION ON EVERY PART OF THE FRAME AND USED A TOTAL LENGTH OF EXPOSURE OF ABOUT 3 MINUTES, A VERY LENGTHY EXPOSURE, EVEN AS COMPARED WITH THE 90-SECOND EXPOSURE FOR HIS "CAROLINE" SHOT ON PAGE 27. THE AMOUNT OF DIFFERENCE THIS INCREASE IN EXPOSURE TIME MAKES IS OBVIOUS, GIVING A MUCH MORE HIGH-KEY IMAGE HERE, AND THE DIFFERENCES IN TECHNIQUE USED ARE ALSO APPARENT.

► *The exposure time of 3 minutes does not represent the total time taken to enact the whole procedure. Yet more time would have passed between each burst of illumination while the photographer got into position, changed the light brush head, and so on*

► *The stillness of the model during such a long exposure is vital and the pose was chosen partly as a practicality - a position the model could hold comfortably for the duration of the exposure*

First the basic, broad light brush head was used on a tripod to illuminate the model overall, for 30 seconds. Then a focusing attachment for the light was used to paint-in light more specifically on the model's arms and legs. This took 40 seconds, using smooth hand-manipulated movements, with the light source 40cm away from the model, giving good control over the exact highlights on the limbs.

Finally, the swirling paths of light on the blue and red background were created by using quick sweeping movements to make discrete streaks of light across these areas.

Photographer's comment:

When using a light brush it is important that the model keeps absolutely still and for this reason the poses possible are a bit limited.

Photographer: **Raul Montifar**

Use: **Calendar**

Camera: **Mamiya RB67**

Lens: **180mm**

Film: **EPP 100**

Exposure: **f/11**

Lighting: **Electronic flash**

Plan View

► *Apparent simplicity requires the right model, the right lighting, the right props and the right "look"*

► *Digital imaging software provides a vast range of filters. It is interesting to experiment and find the right "look" for the right shot*

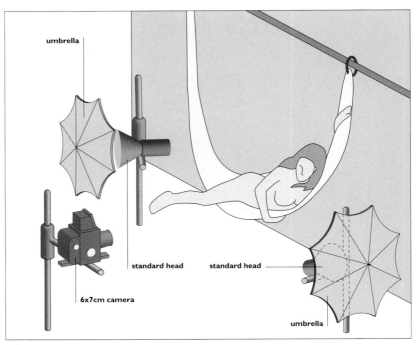

COMPARE THIS SHOT WITH RAUL MONTIFAR'S OTHER IMAGE IN THIS BOOK, "IMPRESSIONIST" ON PAGE 24-25. HERE AGAIN HE HAS DRAWN ON THE IDIOM OF AN EARLIER AGE. LOOKING AT THE PORTRAIT ASPECT OF THE FACE ITSELF, THE DIRECTNESS OF THE GAZE, THE SOULFUL EYES AND FACIAL EXPRESSION AND WISPY, FLOATING HAIR ARE REMINISCENT OF PORTRAITS BY JULIA MARGARET CAMERON AND LEWIS CARROLL.

The characteristic features are the innocence and melancholy air and sense of fragility caused by the slight movement of the model – inevitable during nineteenth-century long exposures, and emulated here by a digital movement filter applied to the image in post-production. The pose and elegant form of the shot have associations from a later period, calling to mind the long-limbed creatures of early twentieth-century art deco artworks. The model is positioned somewhat precariously in a fabric sling and is lit by two flashes with umbrellas. The main source is on the camera right and is set at f/16. Fill is provided from the opposite side by a flash reading f/8.5. The softness comes from the digital finishing of the image.

Photographer's comment:

I used digital imaging through the Macintosh Photoshop.

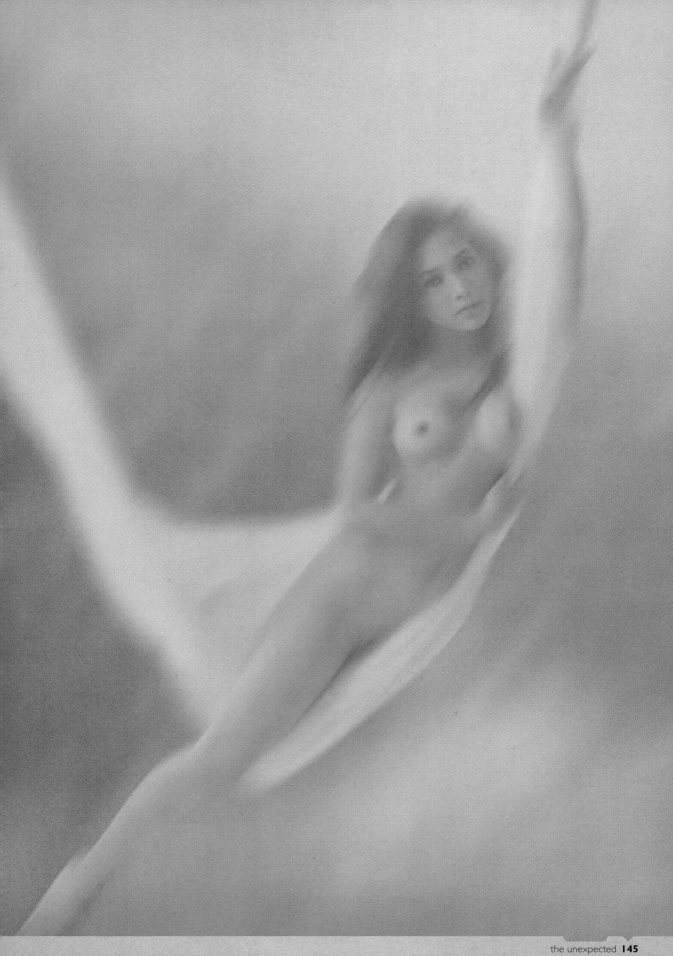

Photographer: **Mike Károly**

Client: **21 GMK "Thomas" Jeans**

Use: **Prospectus front cover**

Model: **Ágota Palcsó**

Art director: **Mike Károly**

Retouching: **Zsuzsa Gönczó**

Camera: **Mamiya RB67**

Lens: **90mm**

Film: **Kodak EPP 100**

Exposure: **Double!**

Lighting: **Electronic flash: 3 heads**

Props and background: **Strong tripod**

Plan View

T I G H T A S A S K I N

▼

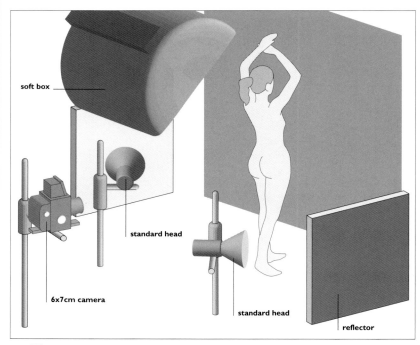

soft box

standard head

6x7cm camera

standard head

reflector

THIS AMUSING, "CHEEKY" IMAGE IS THE RESULT OF A DOUBLE EXPOSURE, THE SECOND IMAGE CAREFULLY ALIGNED WITH THE FIRST BY MARKING THE GROUND GLASS OF THE VIEWFINDER TO HELP REPOSITION THE MODEL. A COKIN B346 WAS USED TO MASK EACH HALF OF THE FRAME IN TURN.

Two standard heads bouncing off silver panels either side of the model illuminate the background as well as giving side lighting to the subject. The haze light above and to the right of the camera gives even, frontal illumination. For a double exposure of this sort it is essential to keep the same lighting in place for both shots for the sake of continuity and consistency of the "look" in the finished image.

The stitching effect of the pocket was drawn on the model's skin by hand, using a make-up pencil.

► It is important not to change the focus or aperture between shots as this will change the very nature of the lens

► A good make-up artist is essential for detailed artwork drawn directly on to skin

Photographer's comment:

Many Polaroid tests – no computer!

Photographer: **Wolfgang Freithof**

Client: **Self-promotion**

Use: **Select magazine**

Model: **Michelle/Ford**

Art director: **Sophia Lee**

Hair and make-up: **Ron Capozzoli**

Body paint: **Claudine Renke**

Camera: **35mm**

Lens: **105mm**

Film: **Fuji Provia 100**

Exposure: **1/60 second at f/4**

Lighting: **Electronic flash: 3 heads**

Props and background: **White seamless background**

Plan View

L A D Y I G U A N A

▼

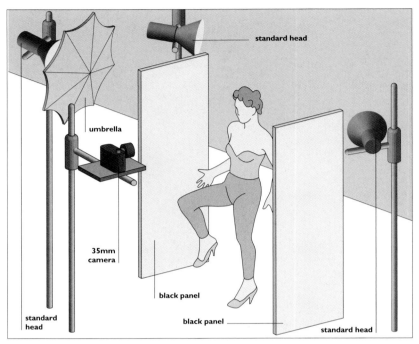

THE CORSET WAS PAINTED ONTO THE MODEL USING A PRE-CUT MOULD ONTO WHICH LIQUID MAKE-UP WAS APPLIED TO STAMP THE DESIGN DIRECTLY ONTO THE MODEL'S SKIN.

The model was standing between two 4x8 foot black panels to ensure that the outside contours remain strong against the white background. Wolfgang Freithof shot some 2½ stops overexposed to give what he describes as 'a painterly quality' to the picture. The main light is a standard head at a height of 12 feet, directly over the camera, shooting through a silk umbrella. The background is lit by two standard heads at 45 degrees, which are set ½ stop over the key lights. This makes sure that the background is very bright and gives some separation between the background and the model's outline.

► *Light shot direct through a silk umbrella gains good diffusion without entirely losing the "point source" look: notice the highlights on the knees merging into softer diffused lighting further along the limbs*

► *Black panels give a very strong fall-off in the light to enhance outline separation*

Photographer's comment:

Collaborated with a cartoonist (Henrik Rehr) to add some extra visual effects. I received many enquiries from this picture from diverse ad agencies and a German publisher.

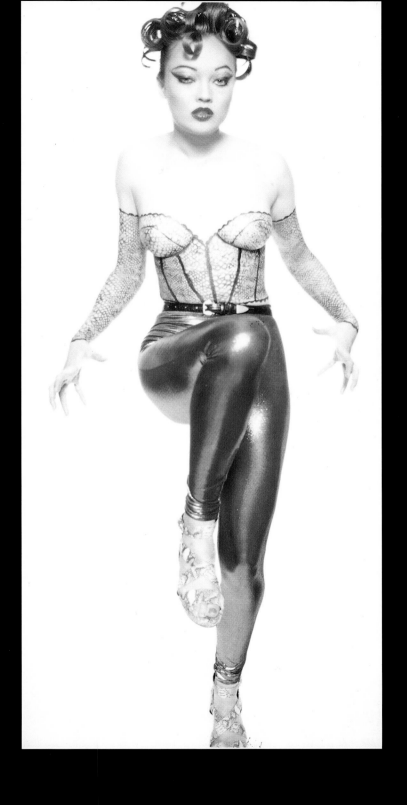

Photographer: **Joseph Colucci**

Use: **Commission**

Design: **Joseph Colucci**

Camera: **Hasselblad**

Lens: **180mm**

Film: **Kodak EPP**

Exposure: **f/8**

Lighting: **Electronic flash**

Props and set: **White seamless paper, pedestal**

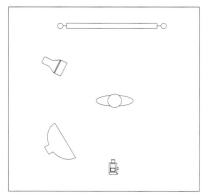

Plan View

Plan View

► *Consistency of lighting on all the component elements is very important*

► *Technology is only as good as the person using it*

P A S S I N G B R E E Z E

▼

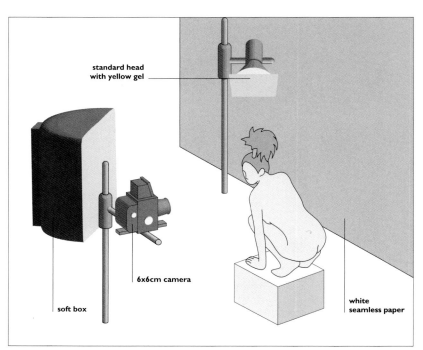

standard head
with yellow gel

6x6cm camera

soft box

white
seamless paper

THIS IMAGE WAS CREATED WITH THE HELP OF PHOTOSHOP. FOR THE BACKGROUND, A SERIES OF COLOURED LINES AND SHAPES WERE DIGITALLY MANIPULATED WITH TWO ELECTRONIC FILTERS, A WIND FILTER AND A TWIRL FILTER TO GIVE THE WHIRLPOOL EFFECT. AN EXISTING PHOTOGRAPH OF THE MOON WAS ELECTRONICALLY PLACED IN THE CENTRE OF THE WHIRLPOOL TO COMPLETE THE BACKGROUND.

The model was posed on a box in front of white seamless paper. The key light is a hard, direct spot, with a yellow gel to camera left. The rim of light visible on the final image around the back edge of the model derives from the white background of this original shot, a small amount of which was left in place when the model was cut out electronically.

The pedestal was photographed on the same set as the model to give the realistic appearance of being in the same realm. As Joseph Colucci modestly says, "Photoshop did the rest."

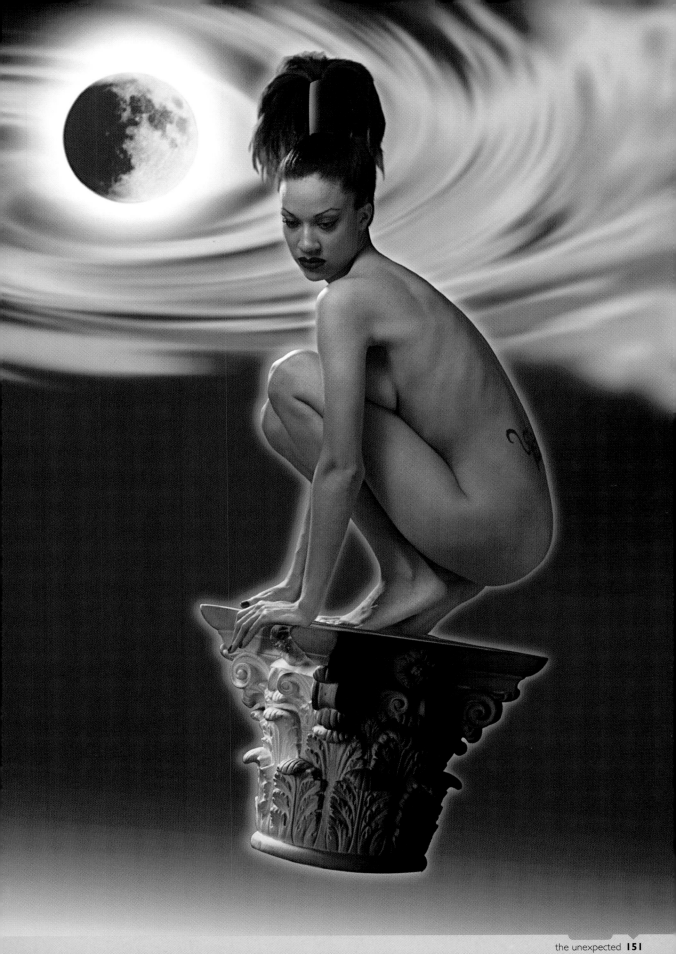

Photographer: **Frank Wartenberg**

Client: **Fit for Fun**

Use: **Editorial**

Model: **Elle**

Assistant: **Bert**

Art director: **Anette**

Stylists: **Laurent, Uta**

Camera: **Mamiya RZ67**

Lens: **360mm**

Film: **Agfa Scala**

Exposure: **Not recorded**

Lighting: **Electronic flash: 6 heads**

Props and background: **White backdrop, Plexiglas on floor**

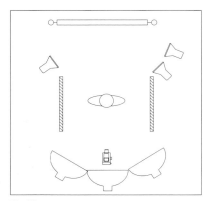

Plan View

► *Agfa Scala is the perfect recording material when a low-contrast image is required*

► *A low-contrast stock can produce a higher-contrast image if a large contrast ratio is applied*

E L L E

▼

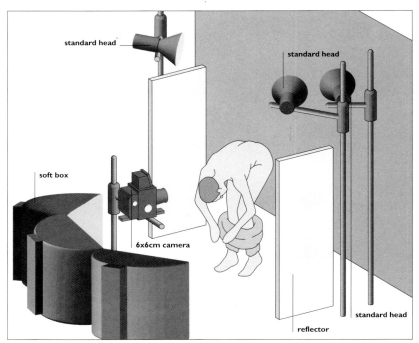

standard head

standard head

soft box

6x6cm camera

standard head

reflector

Tʜɪs ᴡɪᴛᴛʏ sʜᴏᴛ ɪs ᴅᴇsɪɢɴᴇᴅ ᴛᴏ sᴛᴏᴘ ʏᴏᴜ ɪɴ ʏᴏᴜʀ ᴛʀᴀᴄᴋs, ʙʀᴏᴜɢʜᴛ ᴏғғ ᴡᴇʟʟ ʙʏ ᴛʜᴇ ᴄᴀʀᴇғᴜʟ ᴀᴛᴛᴇɴᴛɪᴏɴ ᴛᴏ sᴛʏʟɪɴɢ, ɢʀᴀᴘʜɪᴄ ғᴏʀᴍ, ʟɪɴᴇs ᴀɴᴅ ᴛᴏɴᴇs ᴀɴᴅ, ᴏғ ᴄᴏᴜʀsᴇ, ᴄʜᴏɪᴄᴇ ᴏғ ʟɪɢʜᴛɪɴɢ, ᴛᴏ ᴍᴀᴋᴇ ᴛʜᴇ ᴍᴏsᴛ ᴏғ ᴇᴀᴄʜ ᴀʀᴇᴀ ᴏғ ᴛᴇxᴛᴜʀᴇ. Eᴠᴇʀʏ ʀɪᴘᴘʟᴇ ɪɴ ᴛʜᴇ ᴊᴇᴀɴs ɪs ᴄʟᴇᴀʀʟʏ ᴅᴇғɪɴᴇᴅ; ʏᴏᴜ ᴄᴀɴ ᴄᴏᴜɴᴛ ᴛʜᴇ ᴠᴇʀᴛᴇʙʀᴀᴇ ᴀʟᴏɴɢ ᴛʜᴇ ʙᴀᴄᴋ; ᴇᴠᴇʀʏ sᴛʀᴀɴᴅ ᴏғ ʜᴀɪʀ ɪs ᴅɪsᴛɪɴᴄᴛʟʏ ᴠɪsɪʙʟᴇ.

The model is in the centre of a semicircle of light that is made up of three soft boxes to the front and completed by two silver reflectors, one at each side. Three standard heads evenly illuminate the white background. This is a low-contrast image with a small lighting ratio (about 1:1.5): the key is not significantly brighter than the fill so there is a good tonal range.

The Plexiglas surface placed on the ground creates the opportunity for a reflection of the model to occur on the floor to add interest. From this viewpoint, the shot taken with the camera at about the same height as the model's head – only the reflection of the feet can be seen. If the camera had been higher up than this, more of her reflection would have been visible.

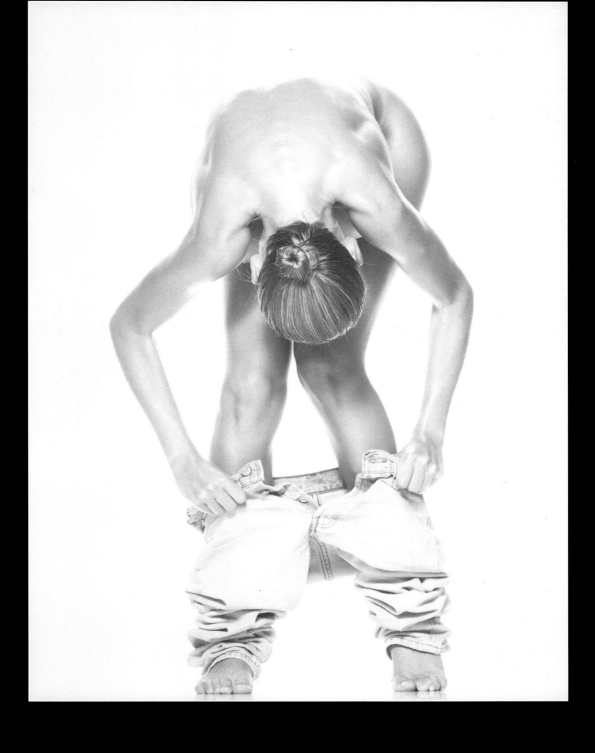

directory of photographers

Photographer: **MICHEL CLOUTIER**
Studio: MICHEL CLOUTIER PHOTOGRAPHE INC.
Address: 4030 ST-AMBROISE
SUITE 344
MONTREAL
QUEBEC
CANADA H4C 2C7
Telephone: +1 (514) 939 9974 (Montreal)
+1 (416) 778 6940 (Toronto)
Fax: +1 (514) 939 2567
E-mail: cloutier@mlink.net
Biography: *Facial expressions, the strength of flexed muscle, the story behind the furrowed brow. The human body is language, desire, passion... I love to explore the mysteries of this magnificent machine, how its subtle movements can create infinite combinations of shape, form and light. Photography allows us to capture the power and beauty of the human form in a way few other art forms can. From initial concept to finished product, Michel Cloutier has both the means and the expertise to ensure fast and professional results. Working easily with characters and fashion models he never fails to capture the chemistry of the moment. Self-employed for the last 10 years, Michel is also the creator of Vertigo magazine, a publication which has served as a showcase for his unique and diverse creative talents.*
New Glamour: p105

Photographer: **JOSEPH COLUCCI**
Studio: COLUCCI'S STUDIO
Address: 264 ACKAWANNA AVENUE
WEST PATERSON
NEW JERSEY
NJ 07424, USA
PO Box 2069
Telephone: +1 (201) 890 5770
Fax: +1 (201) 890 7160
E-mail: joe@coluccis.com
URL: http://www.coluccis.com
Biography: *Joseph Colucci was born in Italy in 1953. He now resides in New Jersey, where he successfully owns and operates Colucci's Studio. Intrigued by all facets of lighting, he loves to create beauty out of the ordinary. He is involved in digital imaging and enjoys exploring all new aspects of it. Photography buyers around the world have appreciated his current web site at http://www.coluccis.com*
New Glamour: p151

Photographer: **WOLFGANG FREITHOF**
Studio: WOLFGANG FREITHOF STUDIO
Address: 342 WEST 89TH STREET #3
NEW YORK
NY 1002Y
USA
Telephone: +1 (212) 724 1790
Fax: +1 (212) 580 2498
Biography: *New York-based freelance photographer with international clientele spanning a wide range of assignments from fashion, advertising, editorial, record covers to portraits, as well as fine art for gallery shows.*
New Glamour: pp87, 149

Photographer: **JUAN MANUAL GARCÍA**
Address: CARRERA 11A #69-38
BOGOTÁ
COLOMBIA
SOUTH AMERICA
Telephone: +57 (1) 212 6005
+57 (1) 249 5843
Fax: +57 (1) 312 7661
Biography: *Juan Manuel García administrador de empresas y fotógrafo desde niño, se hizo profesional por su cuenta y realizando capacitaciones en Europa y Norte América. Su estilo muestra la fantasía que existe en las cosas reales. Hace imágenes exhaustivamente preparadas para lograr ensoñación muy ceñida a la realidad.*
Le apasiona fotografiar gente y moda. Se ha especializado en naturaleza muerta con iluminación muy personal. Ultimamente a desarrollado varios proyectos de fotografía industrial, desarrollando excelentes imágenes para el grupo económico más importante en Colombia, también atiende encargos para McCann Erickson Corp., Young & Rubican, Bates, J. Walter Thompson y todas las agencias de publicidad en Colombia.
Realiza las carátulas de las principales revistas Colombianas. Posee el estudio más grande en Colombia con tres sets y recientemente adquirió una gran estación para fotografía digital.
A recibido numerosos primios en Colombia y Latino América, como mejor fotógrafo de alimentos y distinciones en moda, producto y paisaje.
New Glamour: pp27, 143

 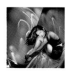

Photographer: **MICHAEL GRECCO**
Studio: MICHAEL GRECCO PHOTOGRAPHY
Address: 1701 PIER AVE
SANTA MONICA
CA 90405
USA
Telephone: +1 (310) 452 4461
Fax: +1 (330) 452 4462
Agent: HAMILTON GRAY
3519 WEST 6TH ST
LOS ANGELES
CA 90020
USA
Telephone: +1 (213) 380 3933
Biography: *Michael Grecco, aged 38, has an extensive background as an editorial and advertising portrait photographer. Along with his advertising work, Michael does regular assignments for Entertainment Weekly, Premiere, Movieline, Rolling Stone, Playboy, Newsweek, Time, Business Week, Forbes and Fortune to name a few. He has been featured twice in Photo District News, most recently in the May '95 issue, as a lighting master. Michael has also been featured in American Photo, had the cover of the 1994 Photo Design magazine awards issue and has won numerous awards, including 1995 and 1996 Communication Arts and several Creativity awards.*
New Glamour: p103

Photographer: **MARC JOYE**
Studio: PHOTOGRAPHY JOYE BVBA
Address: BRUSSELBAAN 262
1790 AFFLIGEN
BELGIUM
Telephone: +32 (53) 66 29 45
Fax: +32 (53) 66 29 52
Agent: (Japan) Mitsuo, Nagamitsu
Telephone: (3) 32 95 14 90
(France) Maryline Kopko
Telephone: (1) 44 89 64 64
Biography: *Photographing on Sinar 4x5 and 10x8 inch, he likes to do arranged set-ups, both in the studio and on location. He finds it most exciting to create effects directly on transparencies.*
New Glamour: pp41, 130-131, 135

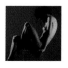

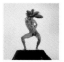

Photographer: **MIKE KÁROLY**
Address: H-1055 BUDAPEST
FALK MIKSA UTCA 32
HUNGARY
Telephone: +36 (1) 11 21 328
Biography: *Freelance photographer. Member of the Hungarian Arts Foundation and Hungarian Photo Designers Chamber (HPDC).*
New Glamour: p147

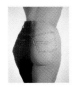

Photographers: **BEN LAGUNAS AND ALEX KURI**
Studio: BLAK PRODUCTIONS PHOTOGRAPHERS
Address: MONTES HIMALAYA 801
VALLE DON CAMILO
TOLUCA
MEXICO CP501 40
Telephone: +52 (72) 17 06 57
Telephone / Fax: +52 (72) 15 90 93
Biography: *Ben and Alex studied in the USA and are now based in Mexico. Their photographic company, BLAK Productions, also provides full production services, such as casting, scouting etc. They are master photography instructors for Kodak; their editorial work has appeared in national and international magazines and they also work in fine art with exhibitions and work in galleries. Their work can also be seen in The Golden Guide, the Art Directors' Index and other publications. They work all around the world for a client base which includes advertising agencies, record companies, direct clients and magazines.*
New Glamour: pp63, 73, 80–81, 93

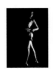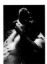

Photographer: **ROB MACLESE**
Address: UNIT 14
HAIGH PARK
HAIGH AVENUE
CHESHIRE
SK4 1QR
Telephone: +44 (0) 161 429 7188
Fax: +44 (0) 161 429 8037
Mobile: +44 0860 683193
Biography: *"Started work at a large Manchester studio back in 1986, sweeping floors.*

Over the years have worked way up the ladder, travelling most of the world, gradually building up clients that are right to work with.
"Areas of expertise do not come into it. I have quite literally shot almost everything, from trucks and cars to in-studio and on-location, through room sets large and small, down to fashion and even food. It is not the subject but the image that matters."
New Glamour: pp49, 113

Photographer: **RON MCMILLAN**
Address: THE OLD BARN
BLACK ROBINS FARM
GRANTS LANE
EDENBRIDGE
KENT
TN8 6QP
Telephone: +44 (0) 1732 866111
Fax: +44 (0) 1732 867223
Biography: *Ron McMillan has been an advertising photographer for over twenty years. He recently custom built a new studio, converting a 200 year old barn on a farm site, on the Surrey/Kent borders. This rare opportunity to design his new drive-in studio from scratch has allowed Ron to put all his experience to use in its layout and provision of facilities including a luxury fitted kitchen. Ron's work covers food, still life, people and travel and has taken him to numerous locations in Europe, the Middle East and the USA.*
New Glamour: pp53, 141

Photographer: **JULIA MARTINEZ**
Studio: VIVA PHOTOGRAPHY
Address: PORTMAN COTTAGE
2 PORT TERRACE
CHELTENHAM GL50 2NB
ENGLAND
Telephone: +44 (0) 1242 237914
Fax: +44 (0) 1242 252462
Biography: *Since completing her photography degree and being sponsored by Kodak, Julia has now launched her own photographic business by the name of Viva Photography. She specializes in model portfolio shots, portraits and beauty photography commissions. She has also found that her career as a model has returned after shooting her*

own model portfolio. She now combines a career in front of and behind the lens, which makes life very confusing but always enlightening! She can be contacted for photographic commissions and model work at the number given.
New Glamour: pp35, 51, 97

Photographer: **ENRIC MONTE**
Studio: ENRIC MONTE SL
Address: PREMIA 15-1
08014 BARCELONA
Telephone: +34 (3) 421 3978
Fax: +34 (3) 422 6633
Biography: *Especializado en fotografía de estudio para publicidad. Actualmente tiene un plato en un edifica modernista de 250 m².*
New Glamour: pp32-33

Photographer: **RAUL MONTIFAR**
Studio: RAUL MONTIFAR PHOTOGRAPHY
Address: SUITE D VERNIDA 1 BUILDING
AMORSOLO STREET, LEGASPI VILLAGE
MAKATI CITY, PHILIPPINES
Telephone: 632 815 6704
Fax: 632 893 2531
Biography: *"My eyes see beauty... and my lens makes sure it is captured forever."*
Raul Montifar believes his work is a testimony to how people perceive certain things. Pictures could expose or hide a multitude of realities and it is up to the photographer to reveal the beauty and diminish the flaw. It is this philosophy that helped make Raul Montifar into one of the Philippines' premier lensmen in the field of advertising. He is at his best working with human subjects and unconventional product shots. His clients are mostly from multi-national agencies such as McCann Erickson, Phils., Ace, Saatchi, J. Walter Thompson.
New Glamour: pp24-25, 145

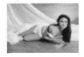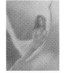

Photographer: **PATRICIA NOVOA**
Studio: IMAGO LTDA
Address: GENERAL FLORES 83
SANTIAGO – CHILE
PROVIDENCIA
Telephone: (+02) 251 0025
Fax: (+02) 235 6625
Biography: *Nace in Santiago en 1957. Licenciada en Arte, Mención Grabado, en la PUCCh y Fotografía Profesional, Nivel Superior, de la Escuela de Foto Arte de Chile.*
Ejerce la docencia desde 1982 en el area de grabado en la Escuela de Arte de la PUCCh. Desde 1982 es profesora de fotografía basica y avanzada en los Cursos de Extensión de la PUCCh. Ha participado en diversas exposiciones de grabado tanto en Chile como en el extranjero.
Además de la docencia, actualmente realiza su creación personal en fotografía y es socia de Imago Ltda, empresa privida dedicada al diseño y la fotografía.
New Glamour: p43

Photographer: **TIM ORDEN**
Studio: TIM ORDEN PHOTOGRAPHY
Address: POB 1202
KULA, HI 96790
HAWAII
Telephone: +1 (808) 876 0504
Fax: +1 (808) 876 0504
Biography: *"Clients ask me, 'Where is your studio?' I laugh and tell them that it's the entirety of Hawaii. When I lived in Seattle I had a studio downtown but found myself waiting for the weather to clear so I could shoot outdoors. Of course, the control of a studio was always comfortable. No rushing because it might rain on me at any moment. I could fiddle with the instruments to my heart's content. I consider the studio experience a great learning chapter in my technical progress but it wasn't till I committed myself to shooting in the environment that things got really exciting. My ideas come from manifestations of daydreams I've had about how things could look. Often I spend seemingly vacant moments (my wife complaining that I'm not paying attention) conjuring up the elements that make up what I consider a compelling image. Maui is my home, Hawaii is my studio. It's funny, just writing about this gets me excited to create some new work."*

New Glamour: pp37, 61, 95, 123

Photographer: **SALVIO PARISI**
Address 1: VIA XX SETTEMBRE 127
20099 SESTO S. GIOVANNI
MILANO
ITALY
Telephone: +39 (2) 22 47 25 59
+39 (2) 48 95 27 16
Address 2: VIA MILISCOLA 2A TRAV. 31
80072 ARCO FELICE
NAPOLI
ITALY
Telephone: +39 (81) 866 3553
Fax: +39 (81) 866 1241
Address 3: VIA SAN CRISOGONO 40
00153 ROMA
ITALY
Telephone: +39 (6) 581 5207
Mobile: +39 336 694739
Biography: *"According to the needs of commercial and editorial photography, which is what I mostly work with, I consider it essential for a photographer to always represent the 'job-fiction' through his own style and in respect of (1) the main idea of the client and (2) the philosophy for a product or name and factory. Assuming these as basics, I always tend during my jobs to refer to a few fundamental 'instruments' such as: a planning schedule, technical precision and overall the final aesthetic effect, in other words a professional working system."*

New Glamour: p89

Photographer: **TERRY RYAN**
Studio: TERRY RYAN PHOTOGRAPHY
Address: 193 CHARLES STREET
LEICESTER LE1 1LA
ENGLAND
Telephone: +44 (0) 1162 544661
Fax: +44 (0) 1162 470933
Biography: *Terry Ryan is one of those photographers whose work is constantly seen by a discerning public without receiving the credit it deserves. Terry's clients include The Boots Company, British Midlands Airways, Britvic, Grattans, Pedigree Petfoods, the Regent*

Belt Company, Volkswagen and Weetabix to name but a few. The dominating factors in his work are an imaginative and original approach. His style has no bounds and he can turn his hand equally to indoor and outdoor settings. He is meticulous in composition, differential focus and precise cropping, but equally, he uses space generously where the layout permits a pictorial composition. His work shows the cohesion one would expect from a versatile artist: he is never a jack of all trades, and his pictures are always exciting.
New Glamour: pp28-29, 71

Photographer: **GÉRARD DE SAINT-MAXENT**
Address: 8 RUE PIERRE L'HOMME
92400 COURBEROIE
FRANCE
Telephone: +33 (1) 4788 4060
Biography: *Has worked in advertising and publicity since 1970. Specializes in black and white.*
New Glamour: pp45, 47

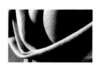

Photographer: **KAZUO SAKAI**
Studio: STUDIO CHIPS
Address: EDOBORI BUILDING 4F
1-25-26 EDOBORI
NISHI-KU
OSAKA 550
JAPAN
Telephone: +81 (06) 447 0719
Fax: +81 (06) 447 7509
Biography: *Born and raised in the Osaka area of Japan. Independent "Studio Chips" since 1985. Traditional until 1992, now uses both traditional and digital to achieve final output.*
New Glamour: p115

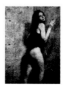

Photographer: **MYK SEMENYTSH**
Studio: PHOTOFIT PHOTOGRAPHY
Address: HAIGH PARK
HAIGH AVENUE
STOCKPORT, CHESHIRE
SK4 1QR
Telephone: +44 (0) 161 429 7188
Fax: +44 (0) 161 429 8037
Biography: *"Cut teeth with 'In camera effects'*
without the nerve for re-touching.
Thankfully someone invented the
Mackintosh. Now run a busy
commercial studio in Cheshire, shooting
a variety of items from cars, trucks,
room sets, still lifes etc. Also do creative
industrial/location photography.
Currently doing work for Reebok,
GPT, Zenica, Pickeneons, ICI,
Medeva, Territorial Army."
New Glamour: p84-85

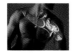

Photographer: **HOLLY STEWART**
Studio: HOLLY STEWART PHOTOGRAPHY INC.
Address: 370 FOURTH STREET
SAN FRANCISCO
CA 94107 USA
Telephone: +1 (415) 777 1233
Fax: +1 (415) 777 2997
Biography: *A lifelong fascination with objects –*
finding and photographing them – is at
the heart of Holly Stewart's work. Her
food photography and still life images
reveal the simple yet extraordinary
truths in the objects of the everyday
world. Since opening Holly Stewart
Photography Inc. in 1991 she has
collaborated on both editorial and
commercial projects, including print and
film advertising, studio and location
photography for a variety of magazines,
including: Sunset, Coastal Living and
Appellation Magazine; and three books:
The Williams-Sonoma Wedding
Planner (Weldon Owen, 1996), The
Art of the Cookie (Chronicle, 1995)
and Beef: New Menu Classics (Beef
Industry Council, 1994). Her work has
drawn local and national attention and
awards, including recognition in CA
magazine, Graphis and the San
Francisco Show.
New Glamour: pp20-21, 64-65,
68-69

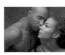

Photographer: **GÜNTHER UTTENDORFER**
Studio: PHOTOGRAPHY AND VIDEO
Address: GELIUSSTRASSE 9
12203 BERLIN
GERMANY
Telephone: +49 (30) 834 1214
Fax: +49 (30) 834 1214
Biography: *"Self-employed for 11 years now.*
I moved to Berlin because this city gives
me great inspiration. My style of
photography nowadays shows my
affinity with shooting movies. If I'm
shooting girls I always try to get one
special side of their character on to
the pictures.
New Glamour: pp117, 126-127, 137

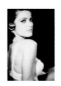

Photographer: **FRANK WARTENBERG**
Address: LEVERKUSENSTRASSE 25
HAMBURG
GERMANY
Telephone: +49 (40) 850 83 31
Fax: +49 (40) 850 39 91
Biography: *Frank began his career in photography*
alongside a law degree, when he was
employed as a freelance photographer
to do concert photos. He was one of
the first photographers to take pictures
of The Police, The Cure and Pink Floyd
in Hamburg.
After finishing the first exam of his
degree, he moved into the area of
fashion, working for two years as an
assistant photographer. Since 1990 he

has run his own studio and is active in
international advertising and fashion
markets. He specializes in lighting
effects in his photography and also
produces black and white portraits and
erotic prints.
New Glamour: pp19, 55, 59, 75,
79, 91, 101, 106-107, 110-111,
121, 125, 133, 153

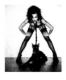
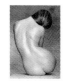

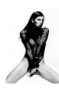
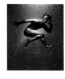

ACKNOWLEDGMENTS

First and foremost, many thanks to the photographers and their assistants who kindly shared their pictures, patiently supplied information and explained secrets, and generously responded with enthusiasm for the project. It would be invidious, not to say impossible, to single out individuals, since all have been unfailingly helpful and professional, and a pleasure to work with.

We should like to thank the manufacturers who supplied the lighting equipment illustrated at the beginning of the book: Photon Beard, Strobex, and Linhof and Professional Sales (importers of Hensel flash) as well as the other manufacturers who support and sponsor many of the photographers in this and other books.

Thanks also to Brian Morris, who devised the PRO-LIGHTING series, and to Anna Briffa, who eased the way throughout.